IMAGES
of America

BEDFORD

Tim —
Welcome to Bedford !

IMAGES
of America

BEDFORD

Shirley Lindefjeld Bianco and John Stockbridge

ARCADIA
PUBLISHING

Published by Arcadia Publishing
Charleston SC, Chicago IL, Portsmouth NH, San Francisco CA

Printed in the United States of America

Library of Congress Catalog Card Number: 2003107579

For all general information contact Arcadia Publishing at:
Telephone 843-853-2070
Fax 843-853-0044
E-mail sales@arcadiapublishing.com
For customer service and orders:
Toll-Free 1-888-313-2665

Visit us on the Internet at www.arcadiapublishing.com

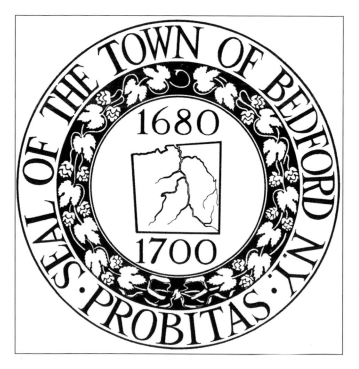

The official seal of Bedford, New York, was designed by James Wood II and was adopted by the town board on June 11, 1898. The date 1680 marks the first purchase from the Native Americans. The date 1700 marks the year of King William III's decree transferring Bedford from the state of Connecticut to New York. The map in the center shows the boundaries of the six-mile square area of town along with the the Croton River. The hop vines surrounding the map commemorate the Hopp Ground Purchase. It is probably the only municipal seal in the United States that shows the map of the area and sets forth significant dates in its history.

CONTENTS

ACKNOWLEDGMENTS

We are grateful for the heritage and natural beauty of the three hamlets that constitute the town of Bedford today. Our history was influenced by generations of strong and committed individuals—from John Jay, who struggled for the high standards of justice of a new nation, to the many individuals today who care about our town and strive to preserve its unique community character. Each generation has been proud of what makes our town special and worked hard to maintain historical context despite the inevitable pressures of population growth and development. We hope that this compilation of our history provides future generations with insight to our past and encourages the continued spirit of town preservation in the future.

This book would not be possible without the extensive photographic collection of the Bedford Historical Society. Any photograph or document not specifically referenced is part of their archives or from the office of the Bedford town historian.

We have so many people to thank for this cooperative effort, first the people in the Bedford community who have shared with us their memories, their photographs, and stories. We would like to thank specifically the following individuals for their contributions of time and material: John Askildsen, the Bedford Garden Club, Bill Banks, Deirdre Courtney-Batson, Stanley Bernstein, Lloyd Cox, Dotty Harder, Kelley Johnston, Jaap Ketting, Tanya Lowe, Chief Thomas Newman, Margie Pierce, Eileen Powell, John Renwick, the Trailside Museum at Ward Pound Ridge Reservation, Wilhelmine Waller, Polly Winans, and Twink and James Wood III.

In addition, for their tireless editorial and personal contributions, we thank the following: Christina Rae (assistant to the town historian), Lynne Ryan (Bedford Historical Society executive director), and Polly Winans.

We are also indebted to those in the present and past who have researched, compiled, and archived our town's records, notably the following: Robertson T. Barrett, Arnhold Bernhard, the Reverend Robert Bolton, Mary Guion Brown, Janet Doe, Frances Duncombe, Robert Erskine, E.S. Folsom, Dorothy H. Hinitt, Herbert Howell, Susan Allport Howe, Katharine Barrett Kelly, Elizabeth Levin, Eloise Luquer, Rosemary Mahoney, Donald W. Marshall, James MacDonald, Julia A. Mead, Halsted Park Jr., Alex Shoumatoff, and James Wood II.

Finally, thanks to Anita Stockbridge and George Bianco who both gave their ideas, comments, guidance, and support to this project.

—Shirley Lindefjeld Bianco and John Stockbridge

INTRODUCTION

The date was May 30, 1901, the place the Montefiore Sanitarium in Bedford Hills, New York. Theodore Roosevelt, the 25th vice president of the United States, looked out at the faces of several hundred dignitaries and Bedford residents gathered to dedicate the new facility and proclaimed, "It is a great thing to have established this home, but even greater to have taught the lesson that the true American is the one who does all that in him lies with all his powers and common sense for the practical good."

In less than four months, an assassin's bullet would end the life of Pres. William McKinley and elevate the "Old Rough Rider" into the presidency. It was no coincidence that Roosevelt accepted the invitation of then-supervisor Isaac W. Turner (a Democrat) to speak at the institution's opening. Roosevelt was passionately committed to America, New York, and the environment. Bedford was a perfect place to express his beliefs at a celebration of like-minded citizens.

Surely a few of these citizens were descended from the original settlers of Bedford who, during the reign of Charles II of England, had proceeded up an old Mohegan Indian trail that linked the salt water of Long Island Sound to the fresh water of what is now northern Westchester County. At the time, all of the land in between was considered to be part of Stamford, and at an inland clearing near to "the bend of the Mahanas River," our founders settled. They negotiated a purchase of 7,673 acres of land from the Native Americans, named the Hopp Ground, and immediately commenced establishing their settlement.

Within two years, a charter was obtained from the General Court of Hartford, which ordered "that the name be henceforth called Bedford." From its inception until the year 1700, a boundary dispute existed as to whether Bedford lay in Puritan Connecticut or Anglican New York. This dispute ended when, by royal decree of King William III, Bedford was "henceforth and forever" part of the royal colony of New York. Other land acquisitions from the Mohegan Indians soon followed, resulting in the roughly six-mile-square township that exists today.

Bedford was soon the thriving center of the county. By 1729, the county seat was established there, and remained so until the village was burned by the British in 1779. Following the Revolution, Bedford shared its county seat status with White Plains. Both towns were deemed to be half-shire capitals until 1868. The Bedford Courthouse, built in 1787, remains the oldest standing government building in Westchester County. It was there that in its first session following the Revolution, one Mr. A. Burr argued for the plaintiff before the judges of the court of common pleas. Burr was none other than the brilliant lawyer and politician Aaron Burr, who, despite becoming vice president of the United States, would be better known as the man who killed Alexander Hamilton in the duel at Weehauken. "Burr had come up from New York, probably on horseback, to try his cases in Bedford. He had a substantial practice in the

Westchester courts at this time," historian Donald Marshall said in an address to the Northern Westchester Bar Association in 1967.

Agrarian before and after the Revolution, Bedford's yeomen dominated the citizenry as reported in the census compiled each decade. The original 22 and subsequently admitted proprietors of Bedford attended town meetings and served their town in such roles as town clerk, supervisor, constable, assessor, pound master, fence viewer, highway commissioner, and highway overseer. Creation and maintenance of roads to and around Bedford Village were major concerns of its residents. Minutes of the town's annual meetings indicate that "repairs of the roads were done by the farmers themselves, each property owner being assessed a certain number of day's work proportional to his land holding. In 1833, William Jay (son of John Jay) was assessed 72 days, Abijah Miller (yeoman) 1/2 day."

Much as the Civil War tore apart families in the border states, so did the American Revolution affect the families of Bedford. Seated on the crossroads of revolutionary conflict, much of Westchester County declared itself to be neutral. Not Bedford. Patriots abounded, and loyalist sympathizers, or refugees, as they were known then, were encouraged to leave. Families were divided, and to this day there remain descendants of those Bedford expatriates who left to form the town of Bedford, Nova Scotia. It was a patriot turned loyalist, James Holmes, who, some reports suggest, aided in the burning of his hometown of Bedford in July 1779. In 1784, a resolution barring loyalists was adopted at the Bedford town meeting. At that meeting, as the minutes suggest, it was "voted that no persons that have been over to the enemy shall come into town to reside. If any have all ready come in they are to be immediately drove out."

With victory and independence, those most involved with the forming of the new nation gained prominence when returning to their homes. In Bedford, such was the case with John Jay. On lands inherited from his parents, Peter Jay and Mary Van Cortlandt, John and Sarah Livingston Jay established their permanent residence in Bedford. They, and their descendants, would have a lasting impact on the town.

Originally, Bedford's center was in the village laid out by its first settlers. As described by Robert Bolton in his *History of the County of Westchester* of 1894, "the present village contains a court house and prison, two churches, an academy, two taverns, three stores, forty dwellings, and about two hundred and fifty inhabitants; it is fourteen miles from Sing Sing and sixteen miles from Tarrytown on the Hudson, forty-four from New York, and twelve from Greenwich in Connecticut, on the sound." Centrally located, a hub of both governmental and commercial activity, situated on land that was both picturesque and productive, Bedford attracted a population committed to preserving its unique character.

Hamlets took root and evolved. Cherry Street and Mount Holly emerged as centers in the north of town. Messrs. Wood and Whitlock moved down the hill from Cherry Street with their neighbors and other immigrants to form around a mill a hamlet later known as Whitlockville. The railroad established stations as it marched northward, and hamlets grew up around the stations. Mount Kisco, Bedford Station (Bedford Hills), and Katonah (old Katonah) were hamlets whose birth and subsequent growth were directly attributable to the coming of the rails. Finally, new Katonah was formed when the City of New York condemned the original Katonah to make way for reservoirs. Residents had to pick up and move their homes a mile south to avoid the actual flood of progress.

The town of Bedford is home to many schools, churches, and 10 nature sanctuaries. Located here are the Caramoor Arts and Music Festival, the John Jay Homestead, over 100 miles of riding trails, numerous lakes and streams, a correctional institution, three volunteer fire departments, three public libraries, an art museum, dirt roads, stone walls, and the stately Bedford Oak.

—John Stockbridge
Historian, Town of Bedford
May 30, 2003

One

THE SETTLERS

In December 1680, 22 men from the Puritan town of Stamford, Connecticut, ventured north on old Mohegan Indian trails and laid claim to an attractive area of land that they named after the fragrant barley hops abundant there. The Hopp Ground was purchased on December 23, 1680, from the native Mohegan chiefs. This sign commemorates the spot laid out for the common use of grazing and other pursuits. By 1682, the settlers applied for a charter, which was given for "that piece of lands to be known as Bedford." The Puritan tradition emphasized community, and a town center soon developed with both private and common land holdings. In the years between 1682 and 1700, the opposing influences of Connecticut and New York were felt in Bedford. A boundary dispute commenced. By 1722, however, with additional purchases from the Native Americans, Bedford incorporated six square miles of land in New York that remain to this day.

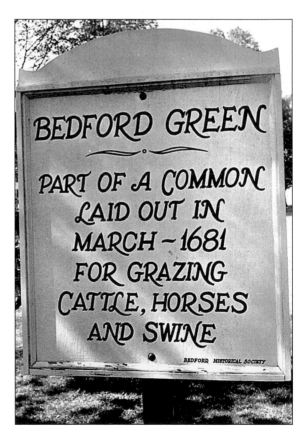

BEDFORD GREEN

PART OF A COMMON LAID OUT IN MARCH – 1681 FOR GRAZING CATTLE, HORSES AND SWINE

BEDFORD HISTORICAL SOCIETY

The settlement of Bedford was begun with the signing of the deed pictured here. It was executed on the December 23, 1680, and reads in part: "Witness these presents that we whose names are under written namely Katonah, Rockahway, Sepotah, Jovis, Tomacoppah, Pannaps, Kakenand, we doe for orselves our heirs executors administrators and assigns and for an in behalfe of al other proprietors of the land commonly called the hopp-ground; doe hereby sel alinate and assigne and set over from us the land above specifyd with all the rights and privilidges thereunto belonging for ever, unto [list of proprietors] . . . in witness of truth we have caused this bill of sale to be made and hereto set our hands and seals the day and date above written."

The purchase price was "twelve Indian cotes, six blankets, 300 guilders wampan, two yards red brod cloth, six yards red cotton and expenses, totaling 46 pounds 16 shillings 10 pence."

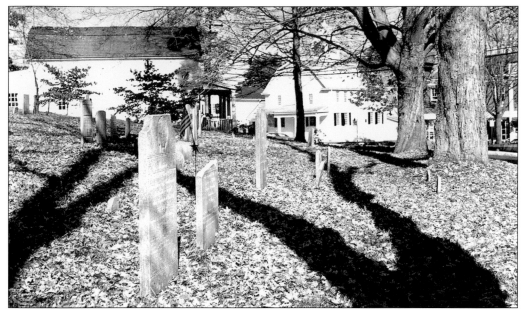

Named after John Bates, who was admitted as a proprietor only three months after the original 22 signed the treaty with Chief Katonah and six other chiefs of the Mohegan (Iroquois) Indians, this cemetery became and still is at the center of Bedford Village facing the village green. It was used for all denominations, and the last date on a tombstone reads 1885. The earliest gravestone still remaining is marked simply 1700 L.M. The Reverend Thomas Denham, the second preacher to serve the original Congregational Society, was buried here in 1689, but his stone cannot be found. Somewhere between 1704 and 1720 the Congregational Society evolved into the Presbyterian Church.

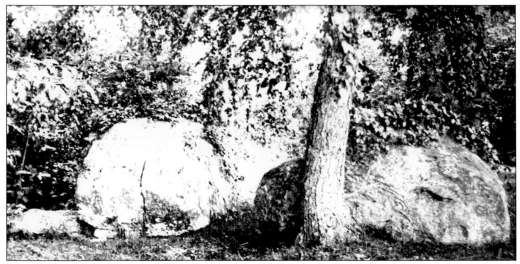

Nine deeds were signed over by the Native Americans to the settlers from 1680 to 1722 for the lands that became Bedford. Only the last of these, in 1722, was not signed by Chief Katonah. It is presumed that the great chief died a few years before this last treaty was signed. Legend tells us that he is buried with his favorite wife beneath two immense boulders just off Katonah Woods Road where, according to Joseph Barrett in an address delivered on July 4, 1876, "with his face toward the rising sun, lies all that was mortal of the great chieftain."

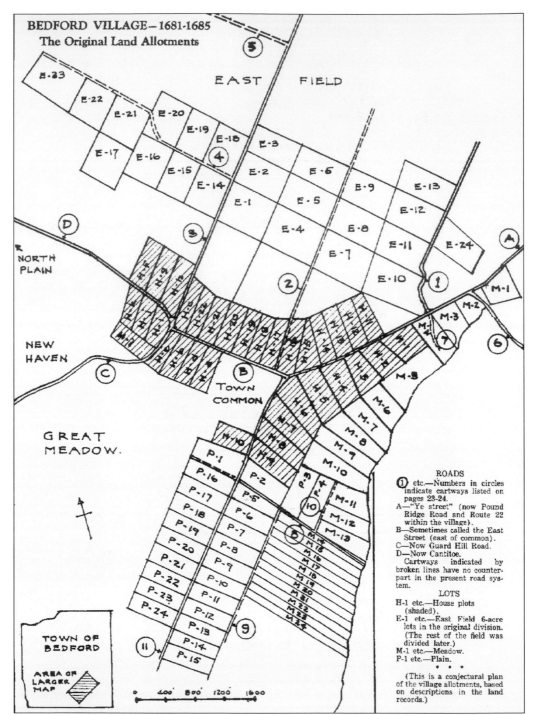

BEDFORD VILLAGE — 1681-1685
The Original Land Allotments

ROADS

① etc.—Numbers in circles indicate cartways listed on pages 23-24.
A—"Ye street" (now Pound Ridge Road and Route 22 within the village).
B—Sometimes called the East Street (east of common).
C—Now Guard Hill Road.
D—Now Cantitoe.
 Cartways indicated by broken lines have no counterpart in the present road system.

LOTS

H-1 etc.—House plots (shaded).
E-1 etc.—East Field 6-acre lots in the original division. (The rest of the field was divided later.)
M-1 etc.—Meadow.
P-1 etc.—Plain.

* * *

(This is a conjectural plan of the village allotments, based on descriptions in the land records.)

The original proprietors of Bedford laid out their village in a typical New England fashion, around a common green. Each man had a home lot of three acres that was to be forfeited if not built on within three years. The lots fanned out from the center green. Original proprietors also shared a planting lot in the east field (marked today by East Field Drive) and also some meadowland for animal grazing.

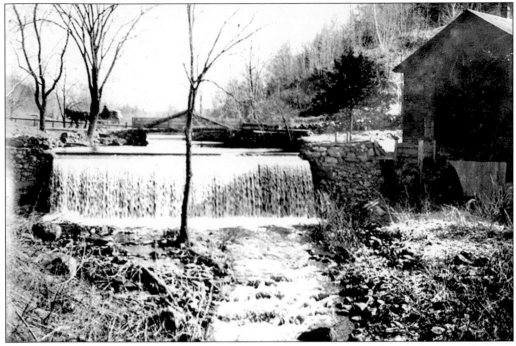

Town records show that in December 1681, Joshua Webb was requested, with the town's help, to build a gristmill. Arrangements were made to build the first mill and dam, financed jointly by the townspeople and Webb. This mill was located on the Mianus River and can still be seen today. The mill was granted to Jonathan Miller in 1723 and appears on modern maps as Miller's Mill.

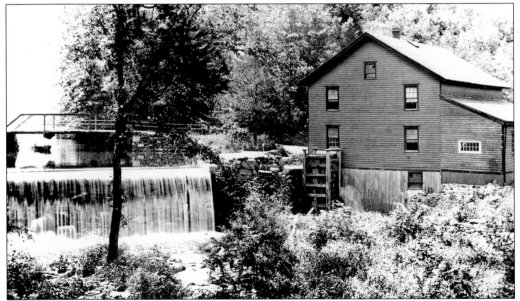

A second mill, later called Matthew's Mill, was constructed to supplement the work. The mill was situated on Beaver Dam and was built by John Dibell. The photograph shows Matthew's Mill in the early 1900s. A third mill was later built on the Cross River and was known as Hoyt's Mill. Matthew's Mill exists as a private residence today, and Hoyt's Mill is now submerged by the waters of the Cross River Reservoir.

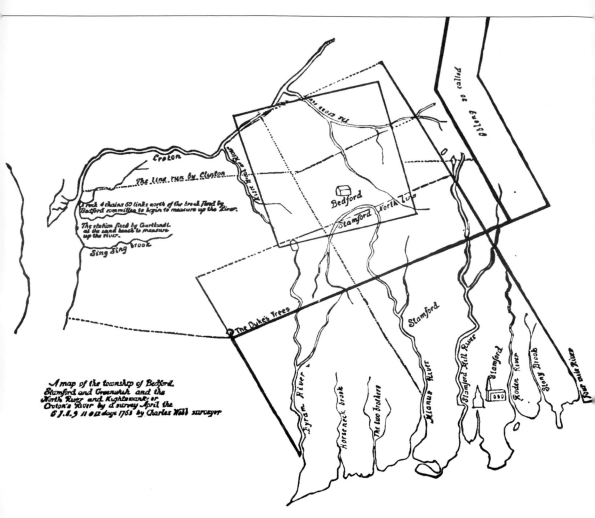

The map contains the following labels:

Croton

The Line run by Clinton

A track 4 chains 50 links north of the brook fixed by Bedford committee to begin to measure up the River.

The station fixed by Courtlandt as the sand bank to measure up the river.

Sing Sing Brook

The Duke's Trees

A map of the township of Bedford, Stamford and Greenwich and the North River and Kightowonk, or Croton's River by a survey April the 6.7.8.9.11 & 12 days 1763 by Charles Webb surveyor

Bedford

Stamford

North Line

oblong so called

Stamford

Stamford

Byram River

Horseneck brook

The two Brothers

Mianus River

Stamford Hill River

Stamford

Roden River

Stony Brook

Four mile River

MAP OF BEDFORD.

In their early Colonial history, Bedford settlers, New England independents (Congregationalists), found that their lands and those of neighboring Rye were directed by the New York Assembly to be part of the parish of Rye in Anglican New York. This confirmed a 1683 agreement between the two colonies that both Rye and Bedford lay in New York. Opposed to this mandate, the citizens applied to be admitted formally to the colony of Connecticut in 1697, upon which the colony concluded to receive them. But in 1700, King William III gave his approbation and confirmation to the settlement of 1683, whereby they were always included in New York. The boundary lines would be disputed for generations, but for all intents and purposes, after 1700 Bedford was part of New York.

14

Two

PATRIOTS AND LOYALISTS

The minutes of the Bedford town meetings from its early origins were lost when the village was burned in 1779 at the height of American revolutionary turmoil. All documents during this time reflecting public opinion were destroyed. Bedford lay in neutral ground between British and American lines, and its citizens were fiercely devoted to either patriotic causes or loyalist preservation. As word spread throughout the colonies of the events of the Boston Tea Party in 1774, revolutionary assemblies such as the Sons of Liberty and the Committee of Vigilance were reinvigorated. Neighbors railed against neighbors. At a town meeting held on April 7, 1784, a vote banned all Tories from residing in the town of Bedford. The properties of these loyalists were confiscated. Several of Bedford's loyalists journeyed to Nova Scotia, where they founded a town that they also named Bedford.

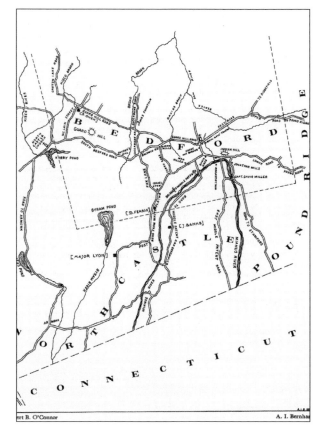

ert B. O'Connor A. I. Bernha

On July 9, 1776, a copy of the Declaration of Independence was received by the Provincial Congress of New York meeting in White Plains. John Jay, seen here, moved that the New York Congress adopt the Declaration. British ships of war were gathering at Tarrytown, only six miles away. Many of the first families of New York were ardent royalists, and the city of New York was under British occupation. The lines were being drawn. Westchester County soon became neutral ground, with the area around Bedford becoming a convenient crossroads between the Hudson River and the Sound, sufficiently removed from the British troops in southern Westchester, but unprotected behind the American lines north of the Croton River.

The major event of the Revolution for the citizens of Bedford was the burning of their village on July 11, 1779. For well over 100 years, historians thought the burning had occurred on July 2, 1779, and that the torching was ordered by Lt. Col. Banastre Tarleton of the British cavalry (pictured here). In fact, the burning was done not on the 2nd, but on the 11th, as discovered by Dorothy Hinitt and Frances Duncombe. In their book, *The Burning of Bedford July, 1779*, published by the Bedford Historical Society in 1974, the authors clearly prove that the village was burned on July 11, 1779. Additional digging into contemporary source material by Ronald B. Reynolds and Donald W. Marshall reveals that the British forces were led by Col. Samuel Birch of the 17th Royal Dragoons, not by Lt. Col. Tarleton as previously believed. From the MacDonald Papers, we have the stories of many patriots present at the burning. The sister-in-law of Colonel Holmes, Sarah MacDonald Fleming, "was a person of exemplary piety, and of the most indomitable courage and perseverance. Three times her dwelling was set on fire by the British during the Revolution, and each time she extinguished it by her own hands and at the peril of her life." (Courtesy Gerard H. Wood Collection.)

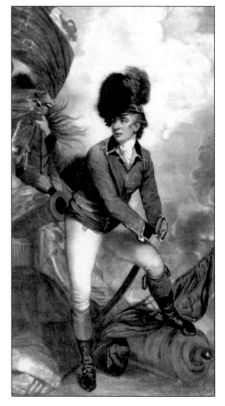

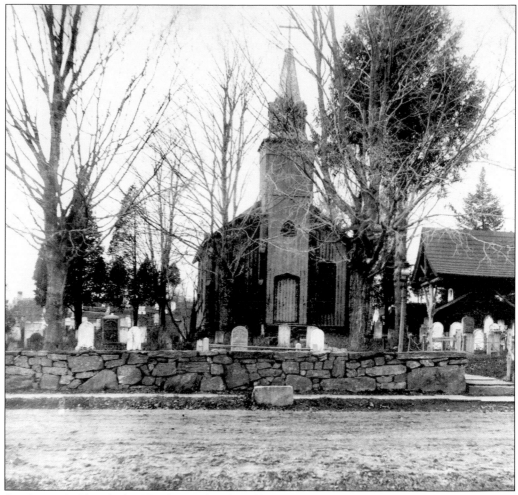

St. George's Church (or North Castle Church) sat at an important revolutionary crossroads. Built in 1761 but abandoned for religious services during the war, the North Castle Church became a focal point for wartime activity. In July 1779, Lieutenant Colonel Carleton, an Englishman, most certainly used the church as a gathering point for the troops that would march on and burn the town of Bedford. Intermittently throughout the Revolutionary War, American troops would use the church as their headquarters. Wounded from the Battle of White Plains were taken in here, and some of the casualties were later buried in the churchyard, which exists today only several hundred yards south of the Northern Westchester Hospital Center. Near the end of the war, French troops under General Rochambeau marching west from Connecticut through Bedford stopped at St. George's Church on their way to join up with General Washington's troops. The combined forces marched south for the victory at Yorktown that ended the war for American independence.

No. of Heads of Families.	Townships.	Free White Males of 16 years and upwards.	Free White Males under 16 years.	Free White Females, including Heads of Families.	All other Free Persons.	Slaves.	Aggregate Total.	More Females than Males.	Mor tha m
13	Morrissina........................	43	17	41	2	30	133	
170	Westchester.....................	279	212	421	49	242	1,203	
102	Eastchester......................	174	160	320	11	75	740	
31	Pelam (or Pelham).............	45	31	84	1	38	199	8	
152	Yonkers	265	220	458	12	170	1,125	
2i3	Greenburgh	330	323	616	9	122	1,400	
109	New Rochelle..................	170	130	277	26	89	692	
33	Scarsdale........................	73	53	113	14	28	281	
65	Mamaroneck....................	108	98	171	18	57	452	
162	Rye	258	154	427	14	123	986	5	
192	Harrison.........................	242	220	453	35	54	1,004	
75	White Plains....................	130	100	218	8	49	505	
303	Mt. Pleasant	501	422	909	8	84	1,924	
400	North Castle....................	608	593	1,205	43	29	2,478	4	
420	Bedford..........................	618	622	1,182	10	38	2,470	
186	Poundridge	247	270	538	7	1,062	21	
260	Salem (now Lewisboro).....	366	326	7.8	14	19	1,453	36	
180	N. Salem........................	266	239	569	15	28	1,058	4	
189	Stephen (now Somers)	343	297	612	7	38	1,297	
262	York (now Yorktown)	389	381	771	28	40	1,609	1	
326	Courtlandt	484	452	905	25	66	1,932	
		5,939	5,320	10,958	357	1,419	24,003	79	

The foregoing is a schedule of the numbers of the heads of families and inhabitants of the County of Westchester by the respective towns as the Deputy Marshall in pursuance of an ordinance of Congress taken the current years 1790 and 1791. *a* Bedford record No. 4.

In Bedford, patriots far outnumbered loyalists, but supporters of both sides engaged in harassment as well as military action. Black Rate, a law under which loyalist property was confiscated to make good for patriot losses, was practiced in Bedford. The most notable Bedford loyalist was James Holmes. James Holmes (1737–1824) was a direct descendant of original Bedford settler John Holmes Jr. He served in the French and Indian War, was the Bedford town clerk from 1763 to 1774, and was the town supervisor from 1772 to 1774. In 1775, Holmes accepted an appointment of the New York Congress to form a regiment of militia for the defense of the state. It was soon clear to Colonel Holmes that the mood of the country was revolutionary, and he could not lend his support. He accordingly resigned his commission and returned to Bedford farm life. In 1778, he was arrested for holding loyalist sentiments but then escaped to Long Island. Here, the story gets fuzzy. Some eyewitnesses of the burning of Bedford made claims that the villain in command was none other than James Holmes.

Other than the burning of Bedford in July 1779, the New York battles in the Revolutionary War were fought over the control of the Hudson River. Bedford, however, maintained its strategic importance as the largest population center in Westchester, with 2,000 people, and as a geographic center of the war theater.

Three

BEDFORD, THE
COLONIAL VILLAGE

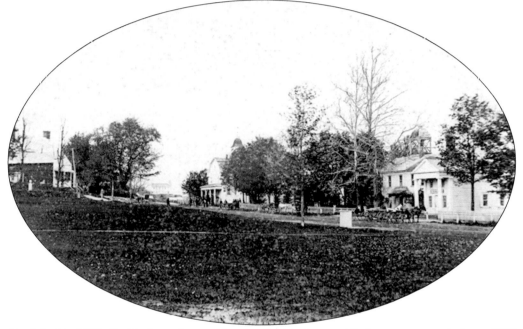

On July 11, 1779, Bedford was burned by the British forces. All the town records from 1722 to 1779 were lost in the fires. Personal accounts of the raids were recorded in the MacDonald Papers and confirm that all but one house in the village were destroyed. A burned shell of life remained of what the Puritan settlers built more than 100 years earlier. Rather than give up to ruin, the discouraged and worn-out farmers and patriot soldiers began to rebuild immediately. Many of the historic buildings we see in the village today appear the same as when they were rebuilt following the fire. During the American Revolution, Bedford was one of the two county seats, the other being White Plains. The two shared county government functions until 1829. County court sessions were held both in Bedford and White Plains until 1870. Bedford was the most important community in northern Westchester and was more populous than White Plains through the early 1800s. This early image, looking north, shows the village green c. 1862. On the left is the general store. The courthouse is in the center. On the right is the Bedford Academy (now the library), built in 1807, and next is Ben Ambler's saddle shop (now the post office).

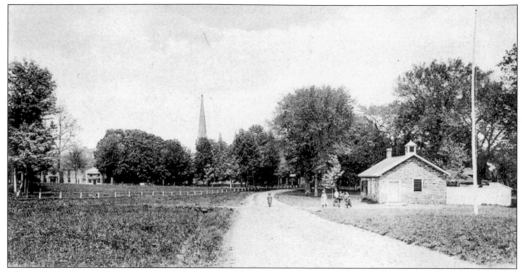

This 1905 image shows the road into Bedford as a small country road. Notice how level the village green is to the roadway. Today, this road is Route 172, and due to many years of paving, it has caused the green to appear concave to the road. The schoolhouse is pictured to the right, where children wait for class to begin. The Stone Jug Schoolhouse was built in 1829 and was active as a school until 1912.

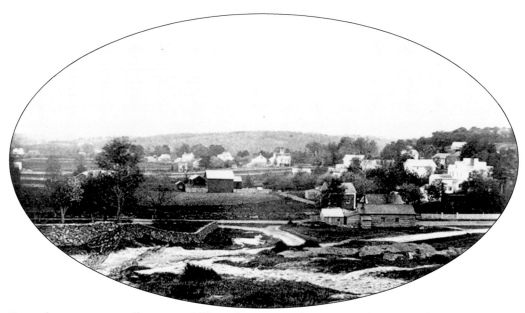

From the written recollections of Eloise Luquer, we have a vivid picture of Bedford Village after the Civil War. "In town was a little shop on the way up Marble Hill—old Jackson's shop. He made coffins and chairs. The Williamson's [known as the George Butler house] had a boy's school in the sitting room." William Hockley's blacksmith shop was located on the north side of town in the square where Guard Hill Road meets the Post Road (Routes 121 and 22). All that remains in this square today is an outcropping of rocks. This photograph shows Bedford Village c. 1867 as seen from the hill where the golf course is now. The building in the foreground is Hockley's blacksmith shop.

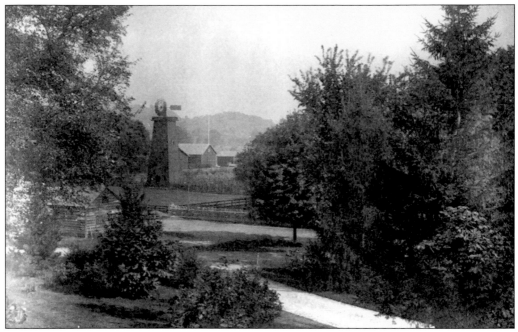

This c. 1860 photograph, taken from Guard Hill Road, provides another view of the highway approach to Bedford Village. William Hockley's blacksmith shop is on the left. The windmill was situated on the grounds of Maplehurst, the home of James Lounsbery. This house still exists today near the corner of Cantitoe and Old Post Roads. (Courtesy John Renwick.)

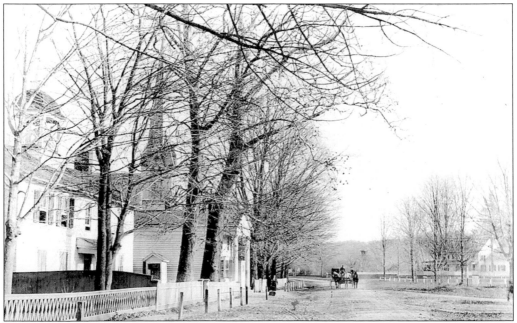

Edward Jackson's stage comes into town on the route to Bedford Station. This photograph was taken in 1902 and shows, from left to right, the Bedford Academy, Ambler's saddle shop, and the Presbyterian church steeple. On the village green sits a small farmer's scale, where local produce is weighed for transport to Bedford Station.

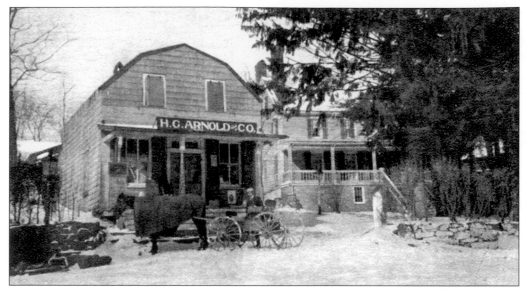

The general store was built in 1838. It originally stood on the north side of the Pound Ridge Road but was moved to its current location in the 1890s, next to Bates Hill Cemetery, or the Old Burying Ground, as it is called today. This country store was at one time the post office and for many years Trumpy's antique shop. Mr. Trumpy sold it to the Bedford Historical Society when he retired in 1968. Behind Arnold's general store sat Jimmerson's Hotel, a popular transient hotel serving such local industries as the Kinkel Quarry.

In more recent Bedford history, Jimmerson's morphed into Mooney's, pictured here in the 1950s. It was a residence and bar with a gas station in front. Eileen Powell, a lifelong resident of the village, clearly remembers that it was off limits to young ladies. "My mother forbid me to go to Mooney's," she said.

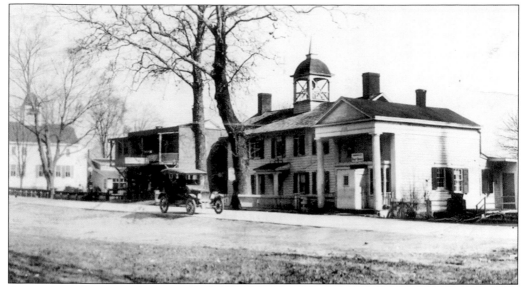

Across from the general store and the Bedford Hotel is Ambler's saddle shop, which is now the post office. In this c. 1915 photograph, notice that the saddle shop is directly next to the Bedford Free Library. The building was moved in 1930 to make way for the new firehouse. The library was originally the Bedford Academy. To the left of the academy is Fowler's Garage, servicing the town's new fleet of motorcars. On the far left is the old courthouse.

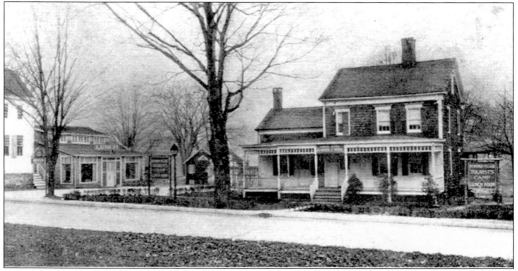

Fowler's Garage was renovated in the 1930s to become the Bedford Village Tourist Camp. Not much is known of this camp or how long it operated. It was later moved to make room for the Empire building. We believe it is now located behind the Empire building. The road between the tourist camp and the courthouse exists today as an access driveway to a home behind the buildings. The little house seen in this photograph next to the courthouse was razed when the courthouse was moved back a few feet from its original footprint to allow for the widening of Route 22.

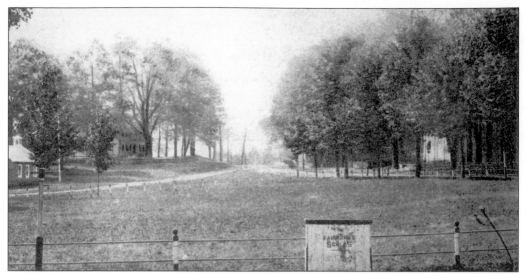

This view of Bedford Village and the village green gives us a glimpse of the tranquility of the village during the late 19th century. The operating schoolhouse is on the far left. On the far right is the Methodist church, which became Historical Hall in 1916. The large platform scale in the foreground was used to weigh farm products to be transported to New York. The two largest farm commodities transported from Bedford were apples and potatoes. Hops never became a cash crop as they did in upstate New York.

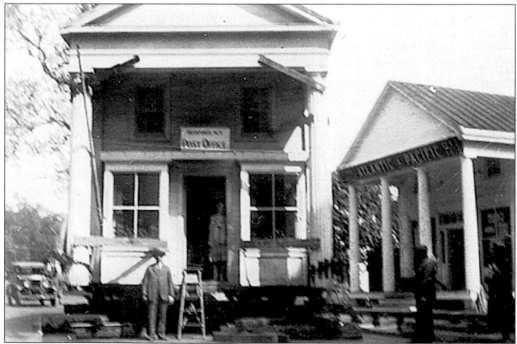

In 1923, the Bedford firehouse was established and set up temporary quarters behind the post office. By 1930, town growth made it necessary to expand the firehouse from its one truck. Plans were drawn up, and it was decided to move the old post office to its present location so that the firehouse could extend to the street. This image shows the moving of the post office as it passes in front of the A & P building along the village green.

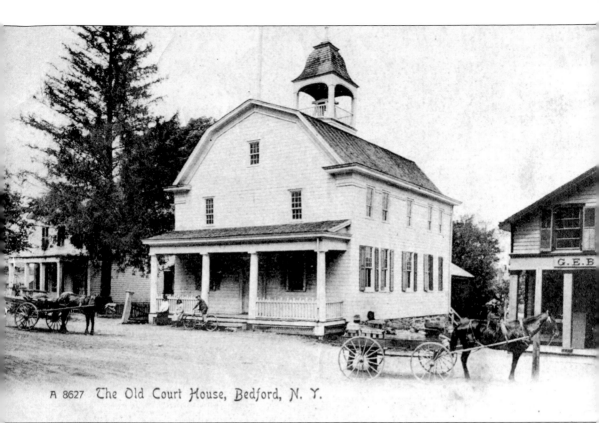

A 8627 The Old Court House, Bedford, N. Y.

The Bedford Courthouse is one of only three 18th-century courthouses remaining in the state today. It was built in 1787 as the village resurrected itself after the burning by British troops on July 11, 1779. Aaron Burr was one of the first attorneys who argued cases here. By the time of the Revolution, Bedford had grown to be the most populous community in Westchester, exceeding White Plains. When the Revolution came to an end, the state legislature gave half-shire status to both Bedford and White Plains and ordered courthouses built in both towns. During these years, Bedford hosted the board of supervisors (until 1829) and county court sessions (until 1870). Bedford ran its affairs under the town-meeting system until 1879, and these sessions were held in the courthouse. When the railroad came to this part of Westchester in the 1840s, it went through White Plains and bypassed Bedford Village. White Plains grew into a city and Bedford remained a quiet country town. The railroad also made travel easy, so it was no longer necessary to have two county seats. The restored courthouse today reflects the heritage of our important past. The ground floor appears as it did in the days of active town government and court. On the walls hang portraits of some eminent jurists, including William Jay (son of John Jay), William H. Robertson, Nehemiah S. Bates, and Aaron Burr. The second floor of the courthouse contains the Bedford Museum, with collections depicting the 300 years of Bedford life and history.

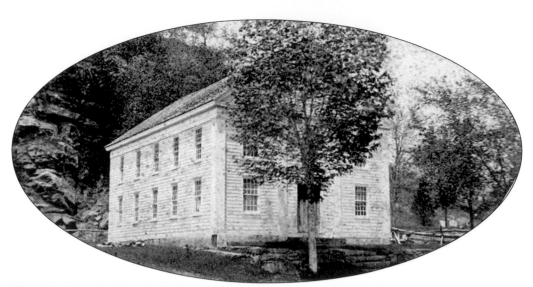

The Old Church of the Methodists at Bedford Four Corners was built in 1806. With a desire to be located in the center of town, the parishioners moved the Old Church in 1837—with the help of 20 yolk of oxen—to the base of Bates Hill. It was originally called a meetinghouse, as the Puritans preferred to follow the New Testament names. By 1916, this congregation could no longer meet its annual needs and decided to sell the church. The church went to public auction and was nearly purchased by an investor wishing to convert it into a transient rooming house. A number of local residents rallied together to purchase and preserve it and, with this act, founded the Bedford Historical Society. This old image was taken in 1867. Notice the church's traditional Greek Revival construction of clapboard siding. The 12-over-12-pane windows display the clean church lines without shutters. The color for everything including the front door is uniformly white.

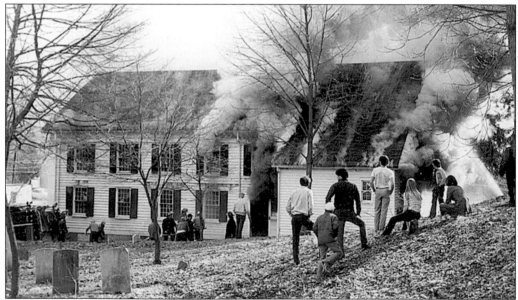

In 1976, the Old Church (Historical Hall) caught fire. Fortunately, the Bedford Fire Department was quick to respond, and the building was saved. After the original details were restored, Historical Hall again became a center for meetings and functions in town.

Bedford Village at the turn of the century was an elegant hamlet with quiet country roads and pedestrian sidewalks. Numerous hamlet socials and town meetings took place. Townsfolk congregated on the green. They attended court sessions and government meetings at the courthouse. They shopped in the local stores. They caught up on affairs as they collected their mail. They met at the town tavern. The children attended lower and upper school nearby. Homes were well taken care of. Fences were merely an ornamental extension of the gardens. With the widening of Routes 22 and 172, however, Bedford Village became a pass-through hamlet for cars racing to get home. Many sidewalks disappeared. The pedestrian traffic has declined, as it has become too risky to cross these highways. This early 1880s view shows the Pound Ridge Road as it approaches the village green. (Courtesy John Renwick.)

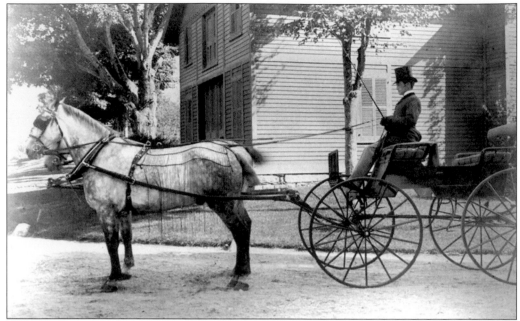

A dashing Richard P. Lounsbery readies his team to visit neighbors c. 1896. (Courtesy John Renwick.)

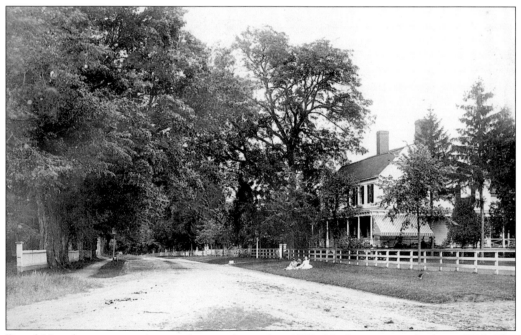

David Hays kept a general store that was burned in 1779. His house was rebuilt in 1785. The late Arthur Ochs Sulzberger, publisher of the *New York Times*, was a descendant of Hays. The house can still be seen today along the Pound Ridge Road. The children picnicking here need not worry about speeding cars along what is now Route 172.

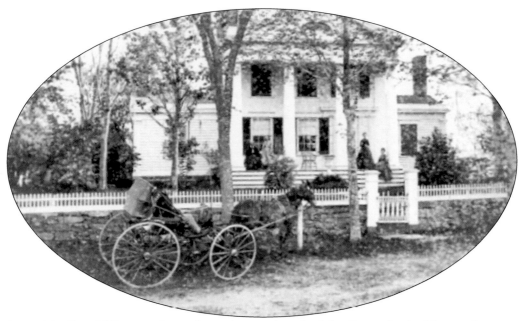

James MacDonald Bates, a descendant of original settler John Bates, finished his residence in 1841. In the photograph above, taken just after the renovation of 1873, the Bates family poses for a photograph before receiving a visitor arriving in his carriage. The property was one of the first to have running water, which was piped from a spring near the neighboring Mianus River. The house exists today and stands elegantly along the Pound Ridge Road.

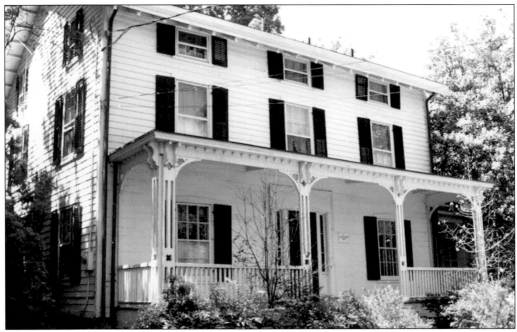

Albert Williamson built his homestead in 1852 along the village green. This house is often referred to as the George Butler house, after a later owner. The Williamsons established a much-needed school for boys that operated until 1872. Class was held in the parlor, and pupils were offered full board in the house.

This house resides on the site of Bedford's original tavern, which was burned in 1779 along with the rest of Bedford. The tavern was rebuilt by loyalist Lewis Holmes in 1785. Holmes's confiscated property was purchased by Benjamin Hays in 1805; he operated the tavern until 1827. It was the second tavern built in the hamlet after the Revolution but in some ways the most prestigious. The Benjamin Hays tavern became the site for entertaining legal visitors to town, and on two occasions, it hosted all of the Westchester County supervisors. The house today, along with the many outbuildings, still looks over the Pound Ridge Road as it approaches Bedford Village.

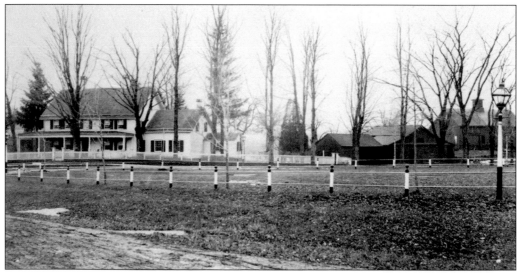

The Benjamin Isaacs house was built in 1799 by one of the most influential members of Bedford's political structure. Isaacs served as town clerk, justice of the peace, and clerk of St. Matthew's vestry. He kept a general store at the west end of town. Later owners of this home included Benjamin Isaacs Ambler, a descendant of an original Bedford settler, and Thomas O'Brien, who was instrumental in starting the Bedford Fire Department and gave the land for St. Patrick's Church.

30

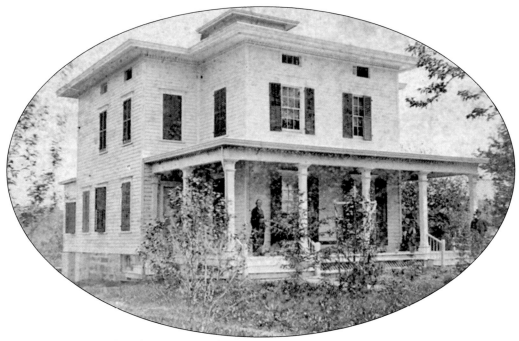

The Presbyterian church manse predates its 1872 Victorian Gothic church (the fourth Presbyterian church) and stands beautifully along the Bedford green. It is still occupied by ministers of the church today. This photograph shows the new home in 1867, with Rev. Peter B. Heroy on the porch. It is said that he moved in the day President Lincoln was shot.

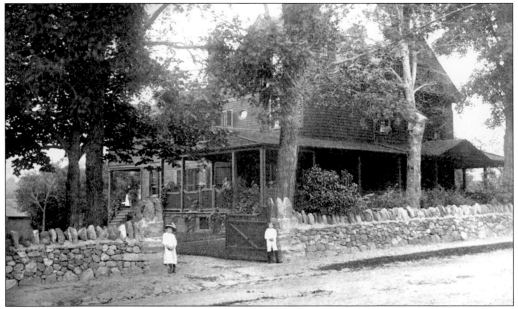

This photograph of the James Lounsbery house was taken in 1867. Maplehurst was directly across the street from the old Lounsbery homestead. The original entrance to the home is on Route 22 just before it reaches the 121 intersection. This entrance has since been closed, but the home still exists today. The wall is much taller today, and the decorative stone top has been altered. (Courtesy John Renwick.)

31

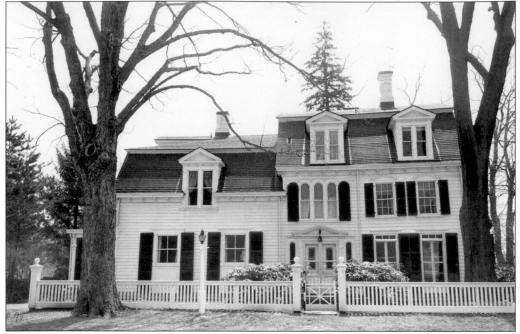

James MacDonald built his homestead in 1794. He was a well-to-do supervisor of the town. MacDonald has given us a written collection of oral histories that is an important historical reference today. His son-in-law, Nehemiah S. Bates, was county clerk and inherited the home.

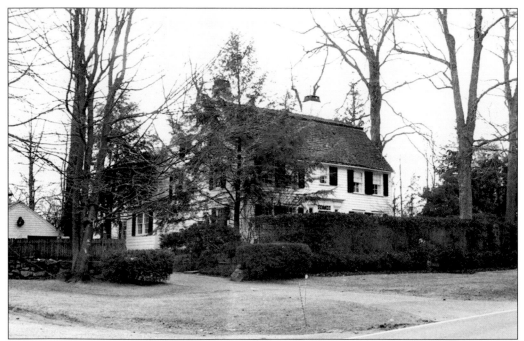

Judge Aaron Read, a county judge and town clerk, built this house in 1785 and lived there until his death in 1854. The gambrel roof is similar to that of the 1787 courthouse. The house stands today in good condition across from Historical Hall.

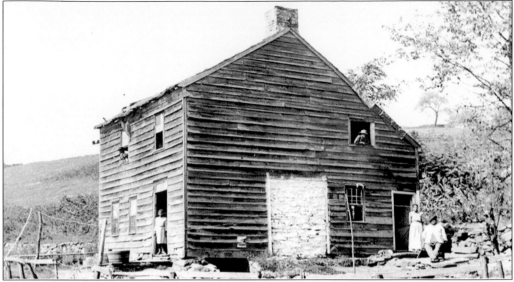

In the mid-1800s, many freed slaves organized a neighborhood around Hook Road. Photographed here is the Teats home, which still exists as a private residence. On the back of this photograph is written the following: "This was the home of Teats, the colored man, who lived on Hook Road. He called himself a 'contractor' but no one ever knew of any contracting done by him. Teats is sitting in the chair at the doorway."

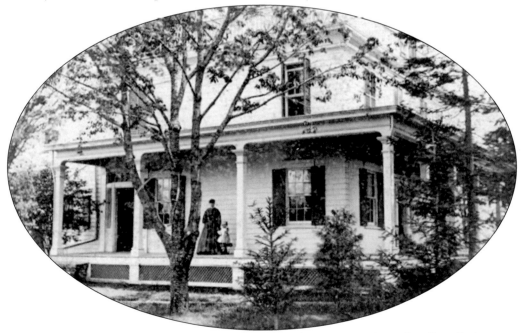

Hezekiah Robertson was a merchant in town and was the great-grandson of William Robertson, who settled in Bedford in 1744. He was also the cousin of Judge William Henry Robertson of Katonah. Just as his cousin did, Hezekiah served as town supervisor. He also held the position of superintendent of schools and was a member of the state senate from 1859 to 1861. This early photograph shows the home just after it was built in 1836. It was located along the Post Road but was likely torn down when Maplehurst was built in the mid-1800s.

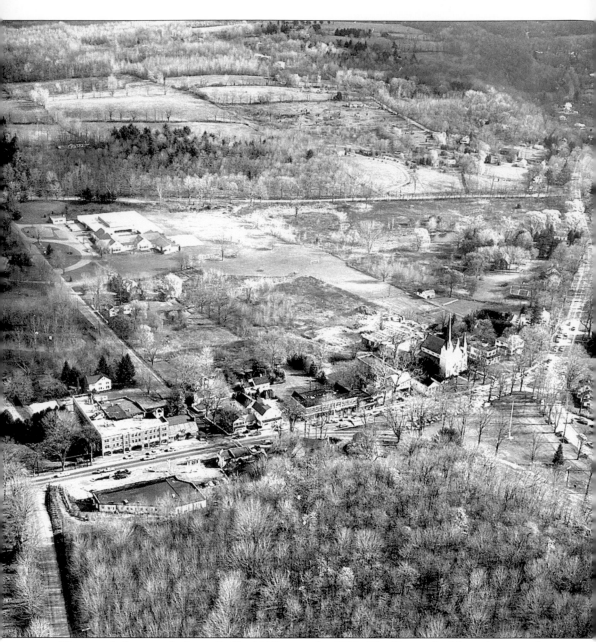

This aerial photograph shows Bedford Village in the 1950s. The Empire building, the movie house, the Arcade building, and the new elementary school have all been built. The horizontal road toward the top is Seminary Road, and beyond that are some of the area's last surviving farms.

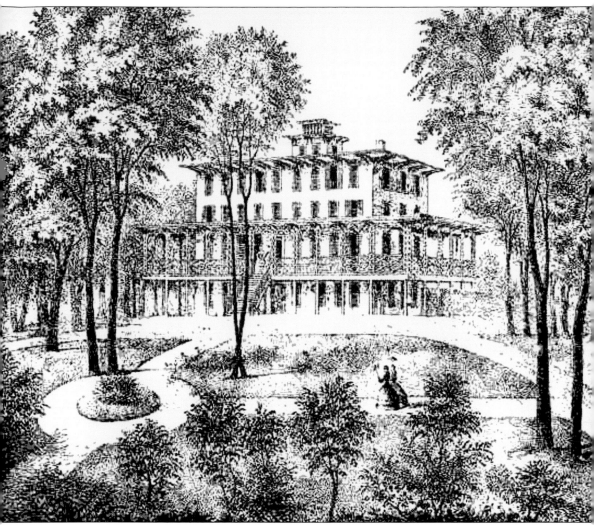

At the top of Court Street upon the hill overlooking Seminary Road, the Bedford Women's Seminary (the Bedford Female Institute) can be seen. This image shows the seminary after it was incorporated in 1856. It operated for many years under the direction of the Reverend Robert Bolton, author of the first history of Westchester County. The Bedford Women's Seminary provided a higher education alternative for well-to-do young women of Westchester County. The building no longer stands.

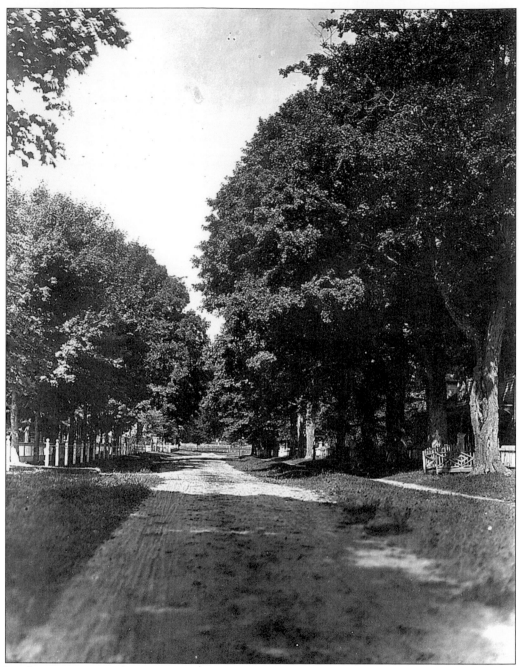

In this 1860s view showing the entrance to the village of Bedford from Pound Ridge are pedestrian sidewalks and tree-lined streets. Most of these maples and oaks were not able to survive the paving of the roads and the subsequent traffic over their root systems. (Courtesy John Renwick.)

Four

BEDFORD STATION

When the iron horse first came to the town of Bedford in 1847, Robertson T. Barrett described the occasion as a march "through what had been corn fields and pasture lots. It was greeted by cheers of the local farmer folk as spectacular evidence of progress, the omen of great things ahead for Northern Westchester." The station stop, which was actually located nearly four miles from Bedford, soon became a center of commerce. The rails brought speedy transportation for produce and fresh dairy products bound for New York City. No longer did farm families have to bring their produce by wagon to Sing Sing for a boat ride down the Hudson. In addition, the milk train made dairy farming in Bedford a big business. A stage service began taking train travelers back and forth to Bedford Village. The area around the station got a post office and a name of its own. For more than 60 years, Bedford Station grew as a commercial hub of the town. On April 1, 1910, at the suggestion of two distinguished local citizens, William B. Adams, owner of W.B. Adams & Son general store, and the Honorable Seth Low, former mayor of New York City and one-time president of Columbia University, the name was legally changed to Bedford Hills.

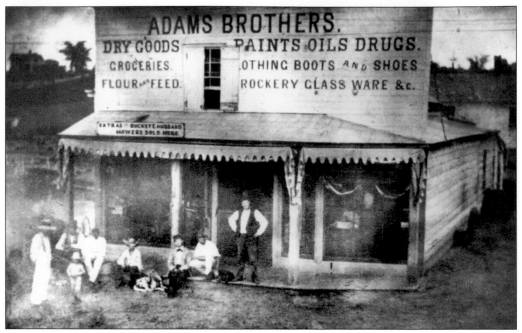

This early photograph shows the Adams store, the first shop in Bedford Station. Notice that the sign says Adams Brothers. The business was established in 1871 by Walker B. Adams and his brother T.C. when they bought out the general store of H.H. Fowler. In 1885, they moved into the building pictured below. In the spring of 1896, T.C. Adams sold his interest to his nephew William B. Adams. The store sold everything from food to dry-good necessities. It was torn down to build a larger second store on the location.

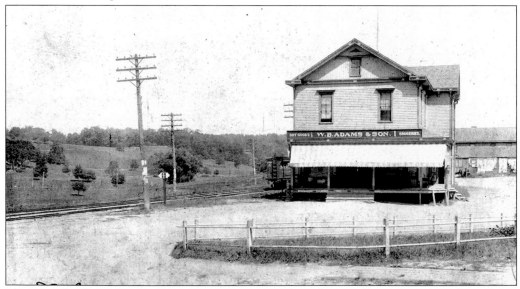

The second Adams store building was erected c. 1880 by Silbert Sciffen and was leased to Adams. The Bedford Musical Society met upstairs. The store was also home to the hamlet's post office, with Walker Adams serving as deputy postmaster, and at the rear was a smithy. This building has also since been torn down, and the Bedford Hills post office now stands in its place. Since the store was so conveniently located by the station, it became a gathering place for the area.

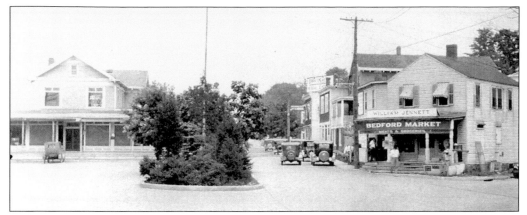

Bedford Station had a number of general stores and markets. They were places to meet neighbors and catch up on town activities. As Bedford Station attracted farmers and middlemen to town, many business dealings were also discussed and established at these markets. (Courtesy Bedford Hills Historical Museum.)

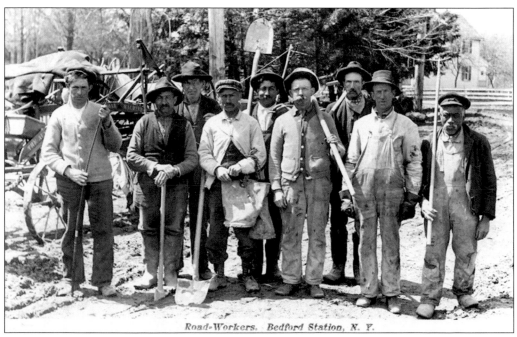

Road workers, mostly immigrant Italians, were employed to build the infrastructure and highways in town. They were also the core labor that built the Croton aqueduct and reservoir. Many of these workers stayed in town and occupied housing along Route 117. This postcard was mailed from Bedford Station in May 1909, and on the back a message reads, "Dear Sister, This is the crowd I am working on the road with every day. What do you think of us and can you recognize me? Hope to see you soon. With love, Your brother Jim." (Courtesy Bedford Hills Historical Museum.)

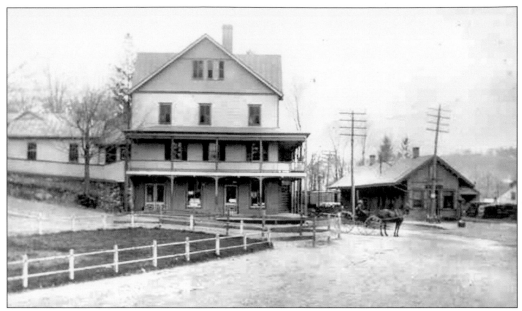

The house shown in the center of this 1899 photograph is Mrs. Philip O'Brien's hotel. It was one of many hotels and transient residences that opened up along the railroad of Bedford Station. This photograph was probably taken from the Adams store and shows the station on the right, with O'Brien's Hotel on the left.

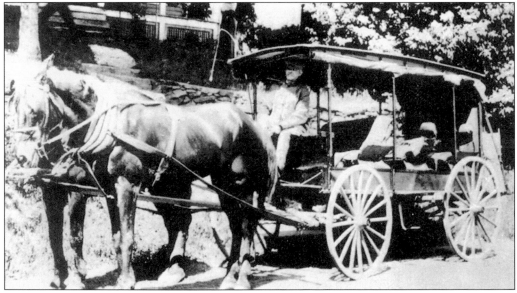

The train came to Bedford Station in 1847. It was a time before Bedford Station had a hamlet community. The station served local farmers bringing produce to market from the surrounding farms and served the people of Bedford Village wishing to travel to New York City. A stagecoach provided transportation between the station and Bedford Village, four miles away. The original coach was run by A.N. Whelply. Two trips ran per day, and the fare in the early 1900s was 50¢ each way. The next driver was Edward A.P. Jackson. He operated the coach for 25 years, until he was replaced by the automobile. This photograph shows Jackson and his team.

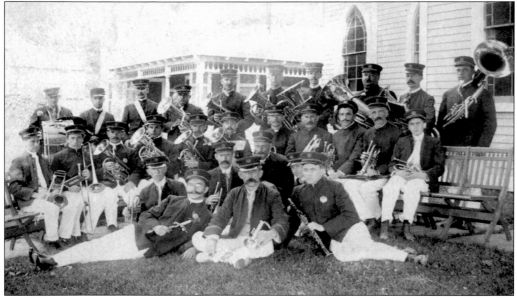

The Bedford Station Band, seen here c. 1910, was formed in 1902 from the Bedford Musical Society and played in all town parades and community functions. Two other bands were formed from the Bedford Musical Society, one in Katonah and the other in Mount Kisco. (Courtesy Bedford Hills Historical Museum.)

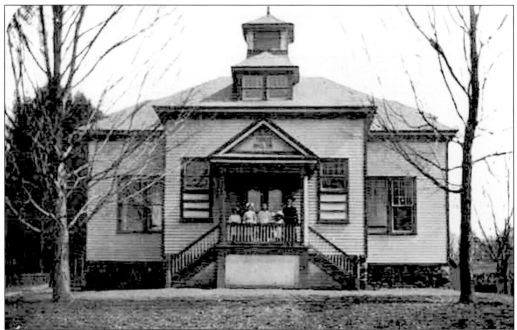

As the community of Bedford Station grew, School District 7 expanded with the construction of this new public school in 1904. It housed six classrooms and divided up lower school students into age and academic groups. An impressive building in its day, it still exists next to the Bedford Hills Elementary School. In 1920, it became the Roman Catholic church of St. Matthias, which continues as a mission church in the Parish of St. Mary of the Assumption in Katonah. (Courtesy Bedford Hills Historical Museum.)

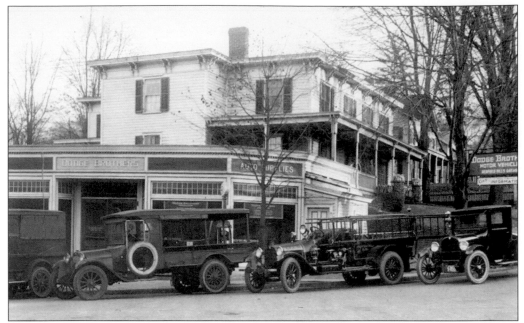

By the 1920s, Bedford Hills had developed into an active and self-supporting residential and commercial community. Roads were paved to support the increasing number of automobiles. The veterans of World War I returned home. Expansion and daily improvements were the order of the day. This photograph shows the handsome array of automobiles occupying the few parking spots available outside the business district. (Courtesy Bedford Hills Historical Museum.)

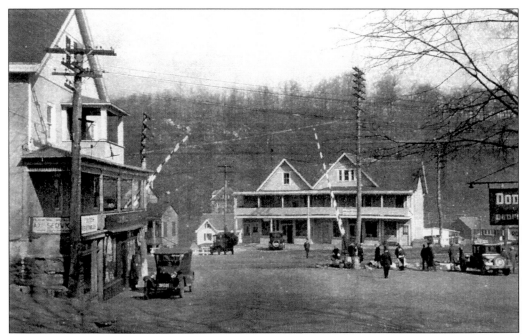

Here is the center of activity in Bedford Station, c. 1910. Looking down Bedford Center Road facing west, one could see the guarded tracks. Adams Street is to the right. (Courtesy Bedford Hills Historical Museum.)

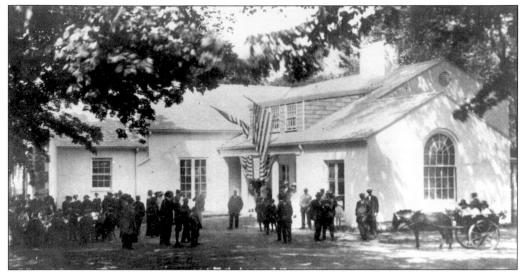

The heightened community activities during World War I demanded a meeting place for organizations such as the Red Cross, the District Nursing Association, and the Boy and Girl Scouts. Also needed in the hamlet was a large auditorium for community meetings and recreation. On May 31, 1920, the Bedford Hills Memorial House (later called the Community House) was dedicated. This photograph shows the opening ceremonies and laying of the cornerstone. The Community House became home to many organizations in town, including the Bedford Audubon Society, the Bedford Hills Woman's Club, the Lion's Club, the American Red Cross, and the American Legion. It also hosted the not-to-be-missed annual costume ball held as a fundraising event for annual expenses. (Courtesy Bedford Hills Historical Museum.)

The New York State Reformatory for Women was established in 1892. It was intended for women between the ages of 16 and 30 convicted of their first crimes. Women over 30 were deemed career criminals and thus were not accepted here. The reformatory gave inmates training in various industries, enabling them to become self-respecting and self-supporting as they reentered society. One remarkable thing about this reformatory was the extraordinary health of the inmates. The impressive hygiene was noted and recorded and used as a model for other institutions throughout the state.

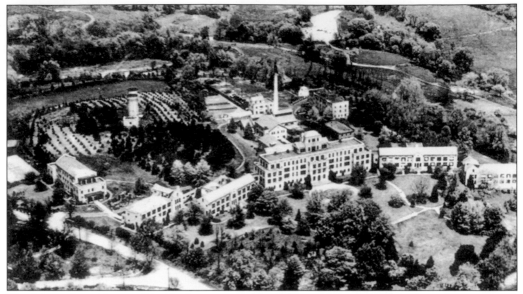

The Montefiore Home of Bedford was opened in 1901 as a sanitarium for tuberculosis patients, where they received treatment for one year. Patients came from surrounding townships as well as from New York City. Bedford was chosen as the site for this hospital because it was remarkably free of this dread disease. The Montefiore Home finally closed its doors in 1958. The institution became the Hillcrest Home for orphaned children. After 20 years, the buildings and grounds were sold again, this time to the religious organization and school Kashau Yeshiva. It is an active Yeshiva today.

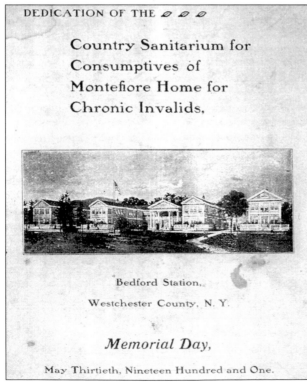

DEDICATION OF THE

Country Sanitarium for Consumptives of Montefiore Home for Chronic Invalids.

Bedford Station,

Westchester County, N. Y.

Memorial Day,

May Thirtieth, Nineteen Hundred and One.

The dedication of the opening of the Montefiore Home (or County Sanitarium for Consumptives of Montefiore Home for Chronic Invalids) occurred on May 31, 1901. The address was delivered by Vice Pres. Theodore Roosevelt. Less than four months after this celebration, Pres. William McKinley was assassinated and the old Rough Rider would become president. (Courtesy Bedford Hills Historical Museum.)

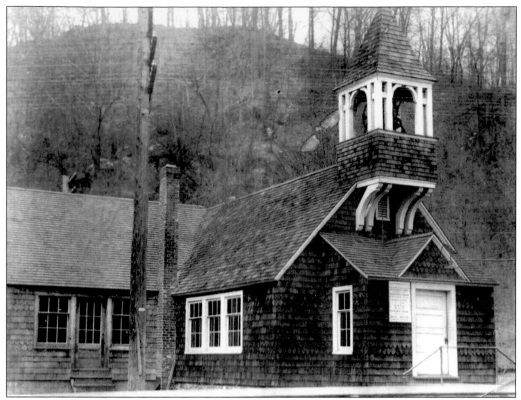

The Antioch Baptist Church was built in 1894 at the junction of Bedford Center and Harris Roads. In 1918, it was moved to the west side of the grade, crossing on what is now Route 117 in Bedford Hills. Ten years later, the church was moved again, this time to Railroad Avenue, north of Depot Plaza. In 1976, the congregation moved with the purchase of the United Methodist Church on the corner of Church and Main Streets, which became the new Antioch Baptist Church. (Courtesy Antioch Baptist Church.)

This photograph shows the Union Church in 1887. It was built in 1858 for the congregation of the Methodist Episcopal Church of Bedford Station. In 1885, a new and larger Methodist church was built and the Union Church was moved a block away to become a private residence.

The homestead of William B. Adams is shown on the knoll above the business district at the corner of Hill Street. Today, it exists as a restaurant.

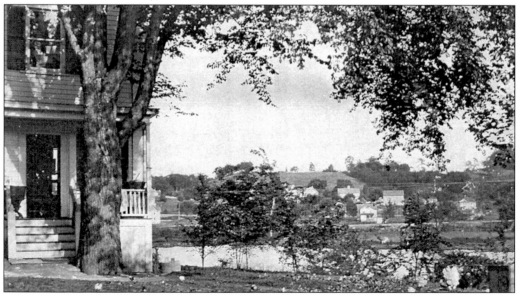

The Bedford Hills Memorial Park lake was known as Lake Marie. The property has had a number of owners, but at the turn of the century, the Metcalfes of New York City were the last private owners before it became a town park. Mrs. Metcalfe was a famous actress known as Bessie Tyree. Her husband, James, was a theater critic for *Life Magazine*. They became involved in many civic organizations and were founding members of the Bedford Hills Community House. Mrs. Metcalfe was an early member of the Bedford Garden Club. The Metcalfes sponsored many fundraising events to support local organizations. This early 1900s photograph, taken from their house, shows Lake Marie. (Courtesy Bedford Hills Historical Museum.)

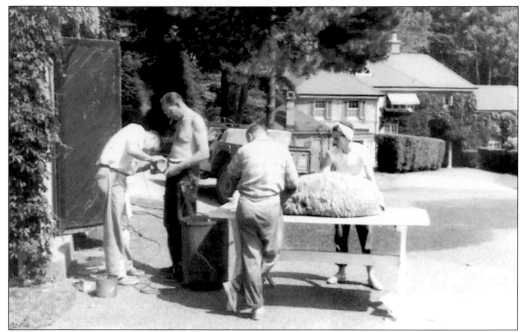

The Vincent family of Bedford Hills gives us a glimpse of the daily life in town. This *c.* 1955 photograph shows the family shearing sheep. Pictured, from left to right, are Robert Jr., Robert Sr., Pete, and Betty.

Another family that has resided in town for generations is the Cox family. James Cox settled in Bedford in the late 1800s because it reminded him of the horse-hunt country of his native Ireland. Shown in the photograph are two of his three children, Jim on the left and Lloyd in the center. Lloyd Bedford Cox became active in the insurance and real-estate industries, establishing a business in Bedford Hills. His son, Lloyd Jr., later took over his business.

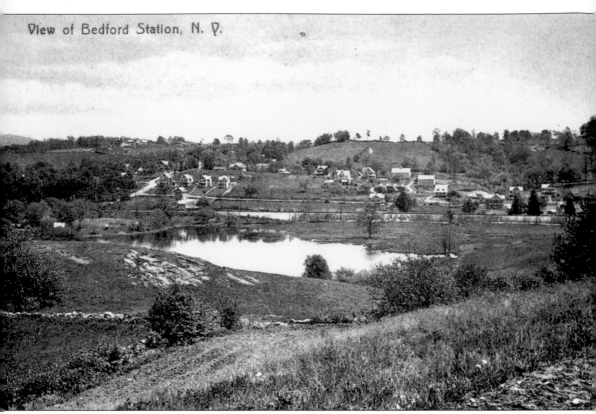

View of Bedford Station, N. Y.

The bucolic scenery of the hamlet is seen in this early 1900s view of Bedford Station, looking south from above Lake Marie. The rail line runs directly through the center, with Main Street coming down the hill on the left side of the photograph. (Courtesy Bedford Hills Historical Museum.)

Five

KATONAH

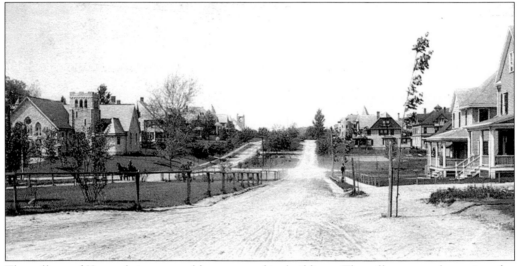

The village of Katonah is not as old as many of its buildings. The village as we know it today is the second Katonah, settled in 1897, while the buildings date to an earlier Katonah settled soon after the railroad came through in 1847. Few buildings in Katonah were built before 1847, but there are many along Cherry Street and in Katonah's outlying districts of Cantitoe and Mount Holly. Cherry Street was the oldest settlement in northern Bedford, mentioned as such in Revolutionary times. The old Katonah lay a half-mile north of the present town. In the 1870s, talk began of New York City's demand for water, which would mean a larger Croton Dam. In 1873 and 1878, reservoirs were constructed north of Katonah on the west and middle branches of the Croton River. The people of Katonah retained confidence that they would be spared from a reservoir constructed on their tributary. In 1892, ground was broken for the new dam. Soon afterward, the village learned that all its land was to be condemned, and 100 homes had to be vacated. Katonah was quick to act. Its inhabitants determined that they would organize to establish a new hamlet. They arranged to move their old homes to new foundations. The city auctioned off the buildings on condemned land, and the residents bought them back. The village migrated to the new Katonah on streets laid down by a noted firm of landscape architects, B.S. and G.S. Olmstead. This early photograph shows the grand Bedford Road.

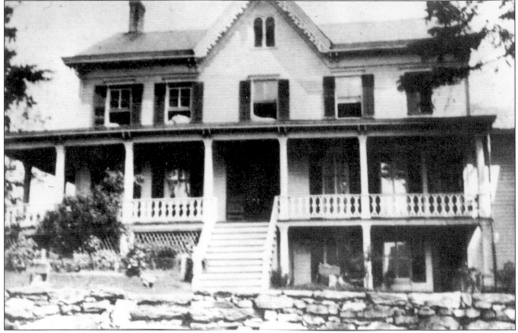

The earliest residents of Katonah lived along Cherry Street, which was an old Mohegan Indian path leading to Muscotow. Zachariah Roberts was one of the first residents and owned land as early as 1705. In the early 1740s, residents came to the Mount Holly section of town. They were John Rundle, John Silkman, Stephen and Jonah Holly, and Daniel Hait. The Cantitoe section also attracted families just south of the Van Cortlandt holdings. Jonathan Miller and William Robertson were among these residents. Pictured above is the Jonah Holly house still standing on Mount Holly Road. (Courtesy Katonah Historical Museum.)

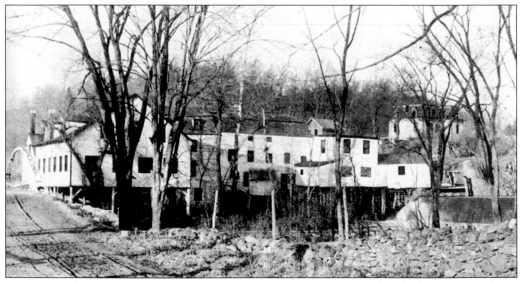

Merchants who set up the first businesses in Katonah were Squire Wood and John Burr Whitlock. They established a general store and tavern in what was soon to be called Whitlockville. They also established a water-operated mill along the Cross River in the early 1800s. It can be seen in this photograph of Whitlockville Road. (Courtesy Katonah Historical Museum.)

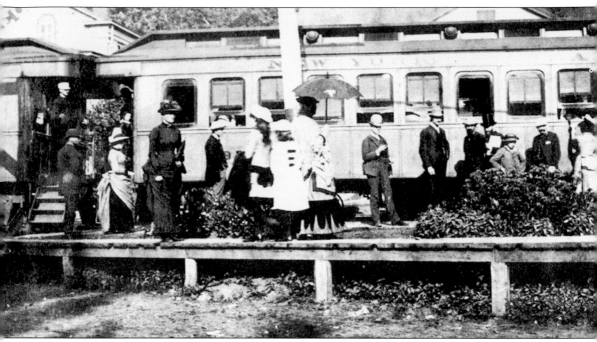

The New York and Harlem Railroad completed its purchase of farmland in central Westchester, and Whitlockville Station was established. Unfortunately for residents of Whitlockville, it was located more than a mile east of their town in a field where not even a farmhouse existed. This open field slowly attracted travelers and merchants and became old Katonah. The photograph above shows an active platform in old Katonah and was taken by E.P. Barrett. (Courtesy Katonah Historical Museum.)

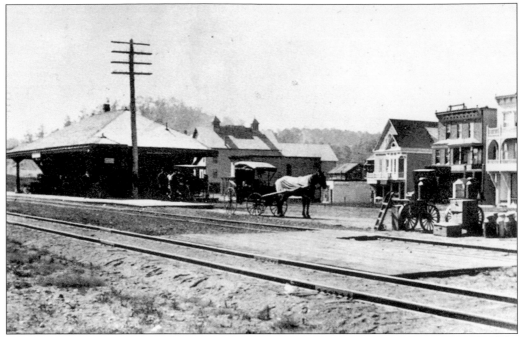

Local farmers in Whitlockville and Mount Holly realized a new market with the arrival of the railroad. They could get milk to the large New York City population quickly. The farms around Bedford became large milk producers. A milk train left Katonah daily. On the lower right, milk cans are ready to be loaded into the arriving milk train. (Courtesy Katonah Historical Museum.)

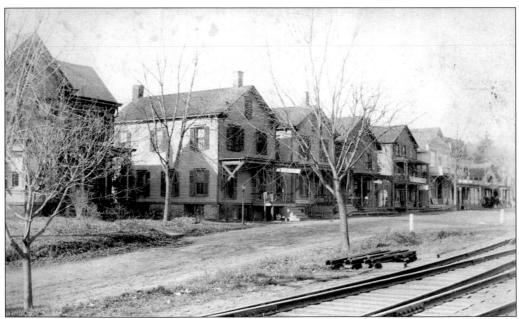

Many abandoned their stores in Whitlockville to establish businesses in old Katonah. A school was built. A row of houses near the railroad sprung up. The post office moved from Whitlockville to Katonah. In 1852, the village's name was officially changed to Katonah.

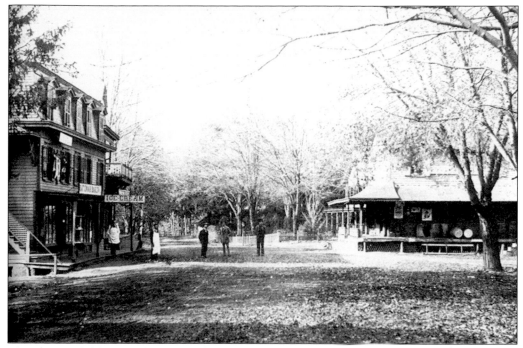

The center of old Katonah is shown here c. 1890. The gentlemen are standing in the middle of Main Street. Old Katonah was surrounded by three streets, which created a triangular center. Railroad Avenue formed one side of this triangle. Main Street, seen here, formed a second side, and River Road formed the third. (Courtesy Katonah Historical Museum.)

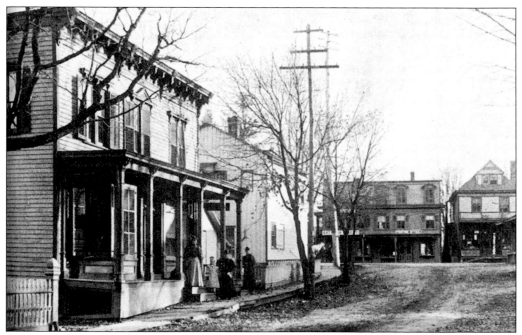

North Street was an extension of the main business triangle of old Katonah. The women stand in front of Miss Crawford's millinery shop. (Courtesy Katonah Historical Museum.)

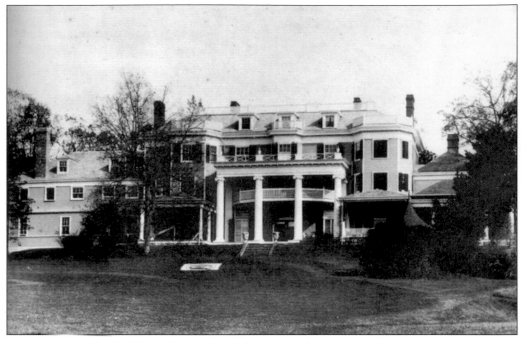

The development of Katonah and the infrastructure, brought by the railroad, also attracted businessmen from New York City. Clarence Whitman was one of these men. He remodeled Katonah's Wood (above), raised cattle, and became an active member of the group planning for the move to new Katonah. Whitman acquired the services of B.S. and G.S. Olmstead to lay out the new village. Here is his house in Cantitoe just after completion. It burned in 1939. (Courtesy Katonah Historical Museum.)

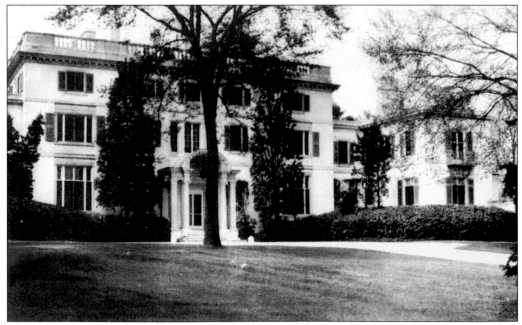

Another wonderful home in Katonah, Girdle Ridge, was the house of William H. Fahnestock. It was built in the early 1900s and was demolished in 1940. (Courtesy Katonah Historical Museum.)

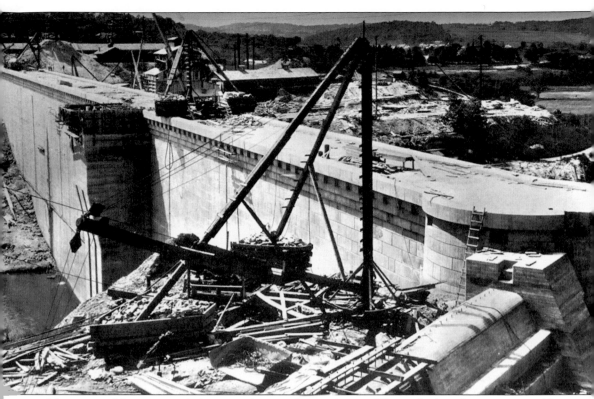

After many false reports, it became clear to the residents of Katonah that their town would be flooded by New York City to build the water reservoir. In 1894, the triangle and center of business in old Katonah was condemned. The deadline to vacate was in less than a year. Financial settlements were not immediately satisfactory, and as a result, it was not until 1897 that the final exodus occurred.

Katonah had a plan. The Katonah Land Company was formed in 1898 by W.H. Robertson, Samuel Hoyt, Albert Hoyt, and Clarence Whitman. A village site was chosen, as seen here. Rules for types of business in the new town included the banning of slaughterhouses, gunpowder factories, skin tanneries, and alcohol sellers. An architect was chosen and foundations begun. (Courtesy Katonah Historical Museum.)

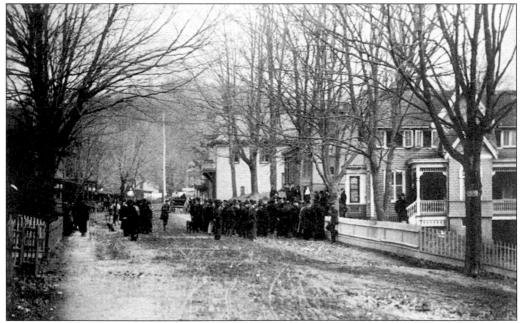

Residents bought back their own houses and businesses at auctions run by the New York City government. Here is an auction in progress on a condemned building on Main Street. (Courtesy Katonah Historical Museum.)

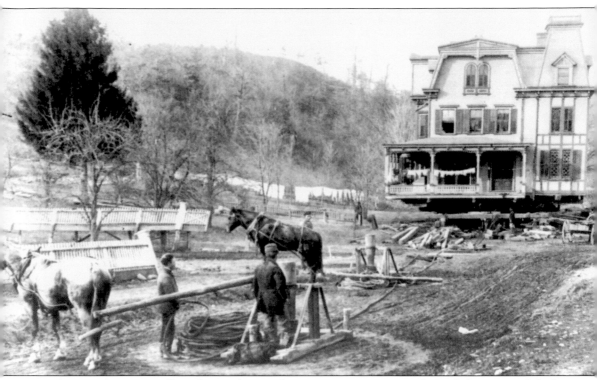

Life carried on normally as houses began their move to new Katonah. Each house was lifted from its foundation. Then the houses were elevated by jacks onto heavy round timbers. The house was pulled along a track of long smooth timbers. Dr. Chapman's house, seen here, has been elevated and is almost ready to be rolled to its new location on the Terrace. Notice that Mrs. Chapman still has laundry out to dry. (Courtesy Katonah Historical Museum.)

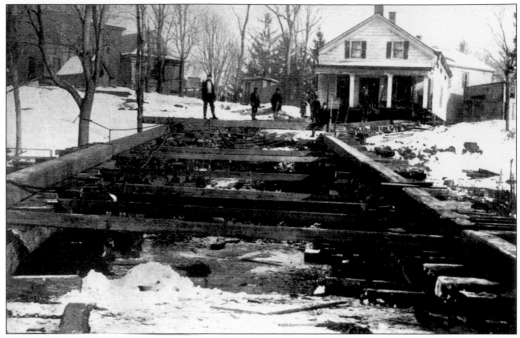

The elaborate track system is in place to move this house from old Katonah. (Courtesy Katonah Historical Museum.)

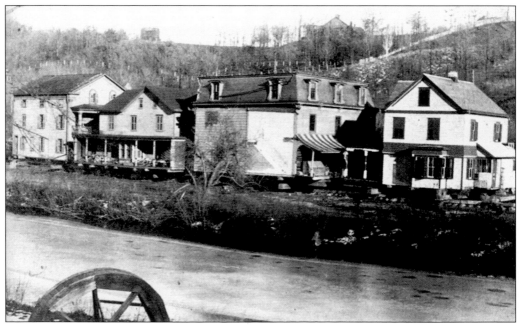

The move from old Katonah was organized and well planned. The entire village participated. Here, we see four houses along the Cross River in the process of moving. Soon, this land would be under the Croton Reservoir. (Courtesy Katonah Historical Museum.)

When the buildings were moved, the dairy business was not disrupted. Social life continued. The Village Improvement Association maintained its lecture schedule. Schools and churches remained full. New people moved to Katonah. Automobiles appeared, and home conveniences developed. Business continued virtually undisrupted. Here is the Doyle Brothers' Seed Store, located at the corner of Katonah Avenue and the Parkway, which was still active during the town's transition. (Courtesy Katonah Historical Museum.)

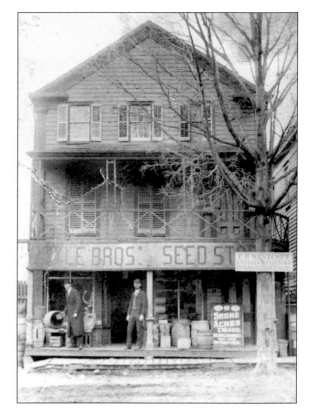

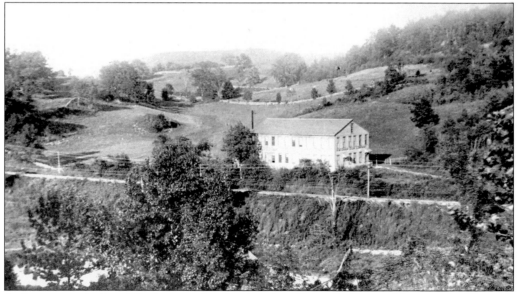

A few non-agricultural businesses also developed in Katonah. Pictured here is the Katonah Silk Company, established in 1890. It manufactured fine ribbons and employed many residents in town. The factory temporarily housed students from the Palmer Avenue School when a fire destroyed the school in 1893. (Courtesy Katonah Historical Museum.)

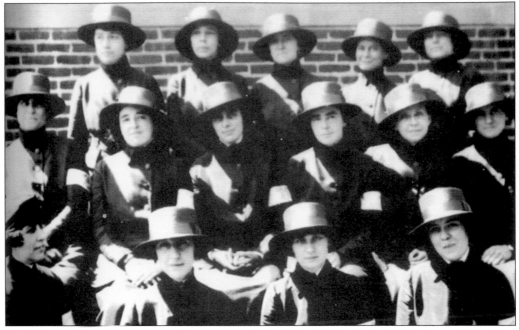

Bedford sent many young people overseas during World War I. In 1918, General Pershing organized the first women's group to serve overseas. The first United States Women's Army Corp. Division was structured after the British WAC. Helen M. Towey of Katonah was one of this pioneer group of 50 female members. Women were represented from all over the nation. Towey is fourth from the left in the middle row. (Courtesy Katonah Historical Museum.)

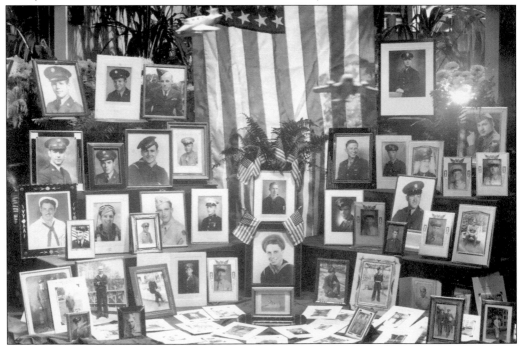

The town was proud of its military troops, as can be seen in the World War II photographs in the local Becker's flower shop window. (Courtesy Katonah Historical Museum.)

Six

THE EVOLVING LAND

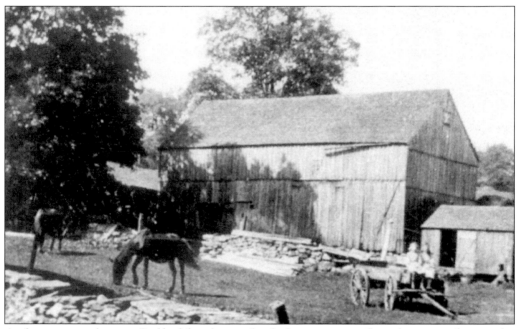

As farmers were leaving Bedford for cheaper land, there was an influx of new people into the area. Much of the open farmland was purchased by New York businessmen who had done well enough to afford a place in the country. The vista was open fields and gently rolling hills as far as the eye could see. The new residents, called "hilltoppers" because they built their houses on top of the hills, revered their new land. They lived in mansions designed by the best architects and filled them with the best art from Europe and the Far East. Many of them were world famous. They looked out at the best views across carefully landscaped expanses of their own property. They also generously supported environmental and charitable organizations, both local and national. Bedford was still not a commuting town but rather a destination for the summer. Just as farmers passed on the land to hilltoppers, the second half of the 20th century saw the large estates divided to accommodate a new group of residents. The fast, electric Metro North train replaced the slow-moving diesel in the 1980s, allowing people to more easily commute daily to New York City. Growth exploded. Some dirt highways were paved. The open farmland and meadows were left to sprout second-growth trees and a new crop of housing. Mills, quarries, and other obsolete businesses were reclaimed by nature or converted to private homes. Thankfully, the new residents also recognized the beauty of their land, the value of their clean water, and the treasure of outdoor life. Housing density has leveled off with preservation of open space and thoughtful planning.

The settlers created farms from the rich Bedford soil. The beautiful Van Cortland lands on Guard Hill Road, shown here, would later become the pastures for Tanrackin Farm, owned by Gustavus T. Kirby, who remarked in his memoirs that as a child, he could sit on the top of Guard Hill and watch the construction of the Brooklyn Bridge.

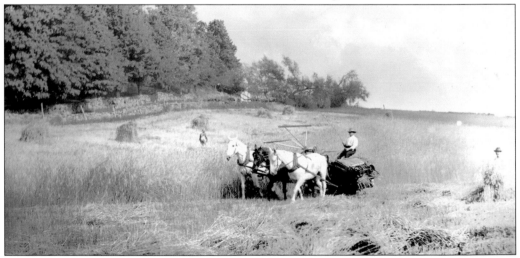

After the decline of farming at the turn of the century, the arrival of the motorcar marked another significant change in the open landscape. Fields that were still kept open to pasture horses were let go when automobiles replaced horse-drawn carriages. Alex Shoumatoff wrote in his book *Westchester* that the first car in Bedford arrived when Harry Barbey brought his Model A Ford to town. This 1880s photograph shows a field in Bedford that is one of the few still remaining open today. Pictured is Palmer Lewis with his team haying to prepare for winter.

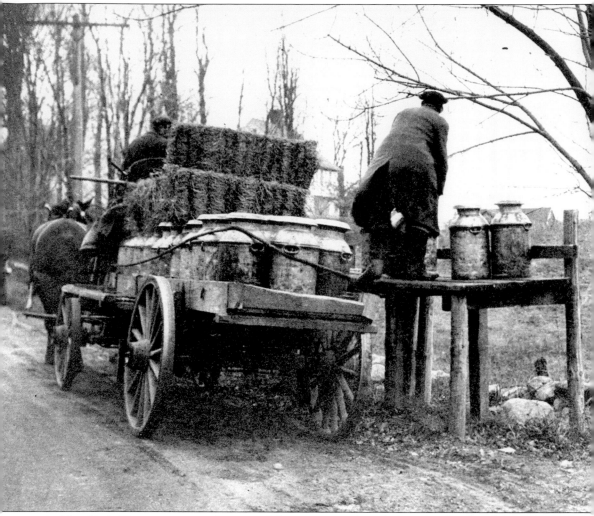

As New York City grew in population and the transport of goods from farmland to the city was made possible by the new railroad, Bedford farming boomed. The rolling hills and flatlands made it ideal for the pasture of cows. Bedford quickly became known as cow country. Many of these farms have disappeared, but fortunately one of the largest still exists. Known as Sunnyfield, it is located just north of Route 22 and operates as a horse facility today.

The railroad ran an insulated train from Bedford to New York, known as the milk train, regularly. The farmers dealt with middlemen who often watered down the milk. One of these middlemen is seen here making his pick-up run from local farms. This photograph was probably taken in the 1890s.

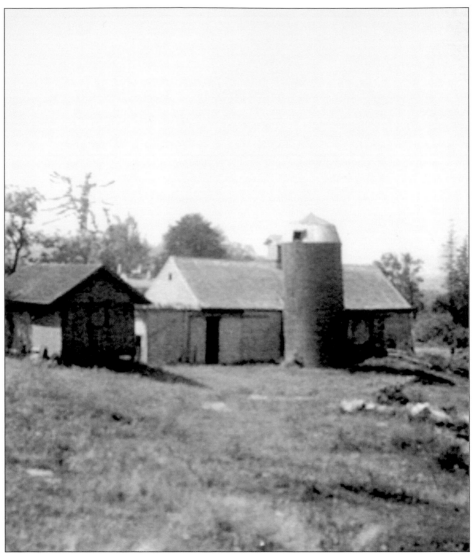

Industries in Bedford grew out of the need to process items grown or collected on farms such as the Wood farm pictured here. Mills were the first to be built by the early settlers. Other early industries were weaving and fulling mills. Every farmer kept a small flock of sheep, and a fulling mill was established to process the wool into clothing. This Bedford fulling mill was located on Broad Brook Road. The crop flax was grown easily in Bedford soil. Flax was worked into linen cloth by farm wives in winter. Leather was also abundant, and farmers became talented cobblers during the winter months. Every farm had a collection of cobbler's tools, and a shoe industry developed in the Chestnut Ridge area. Bedford also had an industry unusual in rural villages. It had two manufacturing silversmiths. Silver was found in several places in town. A mine, owned by Mr. Merritt, was located near the New Castle line. Some of the Bedford pieces by silversmith Ben Smith are on display in the Bedford Museum. (Courtesy Twink and Jim Wood.)

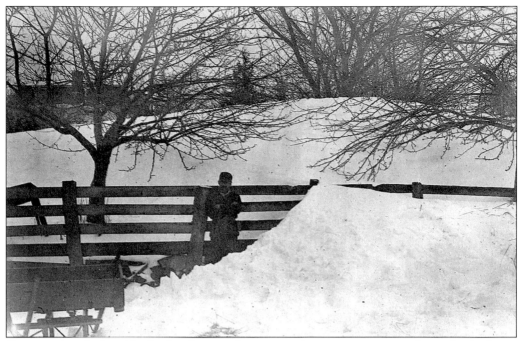

Farmers also dealt with the harshness of nature without any assistance from the highway department. No municipal plows existed to clean the roads within hours of a storm, so travel ceased during periods of great snow. Families sustained themselves with stored food in their pantries. This photograph shows the results of Bedford's blizzard of March 12, 1888. Another noteworthy winter happened in Bedford in 1918. The Farmers Club recorded it to be the year "without a summer." Ice still remained on the lakes well into July of that year.

St. Matthew's Church was closed for weeks during the 1888 blizzard. Schools also closed indefinitely during the harsh storms of winter.

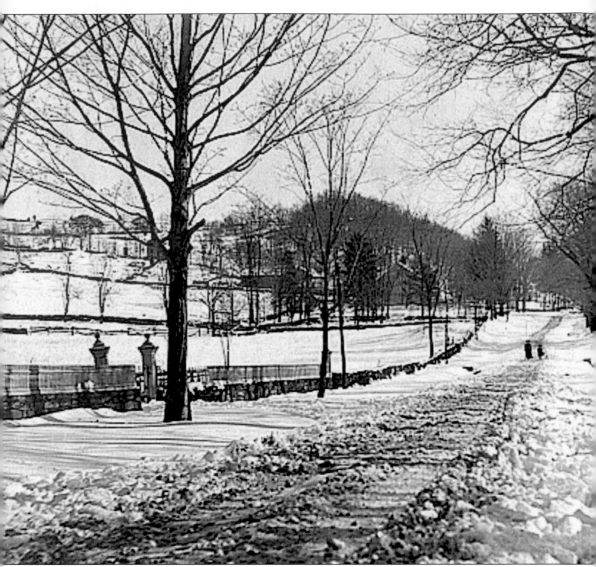

The highway now known as Guard Hill Road was one of the first laid out by Bedford's settlers. It was referred to in 1704 as a highway connecting the green and "Bates Hill toward Hudsons River." It acquired its name during the Revolutionary War when a guard of the Continental army was stationed on the highest point in this area, now called Guard Hill. Cantitoe Street was called by its name in a 1704 grant to Thomas Wood. Bedford Center Road appears in a 1705 deed. Stamford Road was originally a Mohegan Indian path called the Thoroughfare. The Post Road connected Bates Hill with Ogdens Mill at Byram and was laid out in 1723. South Bedford Road was the highway called Frederick's Path. Succabone was a Mohegan Indian trail running from the fork of the Croton River to Long Island Sound near Greenwich. Cherry Street from Harris Road to Woods Bridge was once Muscootah Path. Cross River Road (Route 121) from Bedford Village to Stone Hill Road was described in 1718 as a "public highway," soon to be called the Post Road. Many other old roads existed as Mohegan Indian and Colonial trails. For a complete list and history, refer to Frances R. Duncombe's book *Katonah*. Along many of these old highways are stone fences built by the early farmers. Pictured here is an 1880s photograph of the highway called the Pound Ridge Road. Indian Hill is on the left.

66

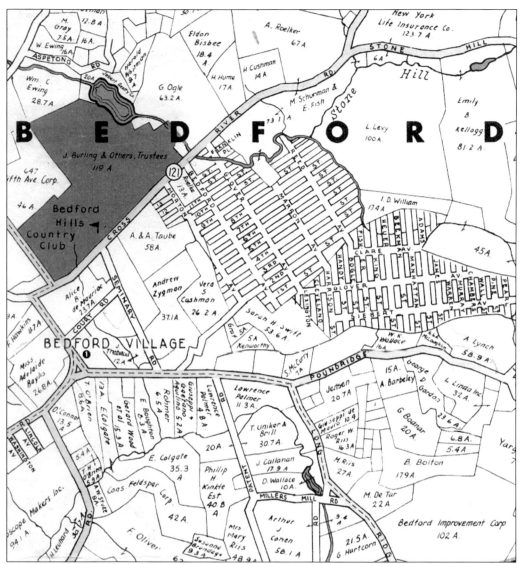

Following the Civil War, rumors were rampant that the New York Housatonic Railroad would come through Bedford Village north along the Post Road to Ridgefield and Danbury with a stop in the village. Since the railroad made a tremendous impact on the hamlets of Bedford Station and Katonah, land speculators began purchasing all the farmland they could. Their proposed subdivisions can be seen on many old maps. Needless to say, this rail line never happened, and the land speculators realized tremendous losses.

This photograph, taken in 1902, depicts Keeler's Bridge over the Mianus River on Quarry Road off Middle Patent. The gristmill is on the left, and a sawmill is on the right. The bridge was heavily traveled and was often rebuilt.

In many of the unfarmed and low-lying areas of Bedford were the most exquisite array of flora and fauna. For several consecutive years in the early 1900s, Bedford won first prize for the best collection of native wildflowers at the famed New York Botanical Garden flower show. In the month of May, 125 species bloomed. Native orchids were common. Fifteen species were collected on one day for exhibit at the botanical show. The watershed south of Bedford Hills was given the nickname "Cranberry Swamp" for the cranberries growing wild there. It is said that a bushel of berries could be gathered in a short time. Now the land has been paved for the Saw Mill Parkway and the railroad. Native animals of Bedford have remained constant with the exception of the virtual extinction of the wolves. Beavers, too, are almost gone. Opossums are a new introduction and are said to come from those turned out at the Bronx Park Zoological Gardens. (Courtesy Ward Pound Ridge Reservation.)

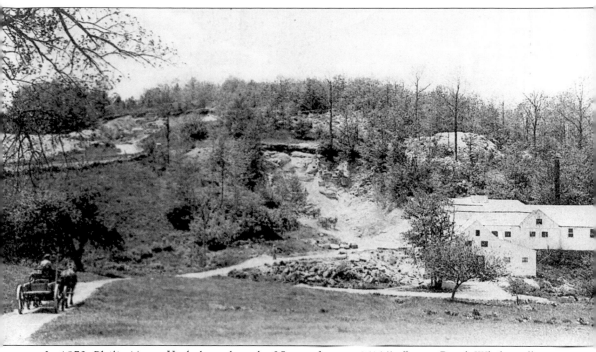

In 1872, Philip Henry Kinkel purchased a 35-acre farm on Middle Patent Road. While walking on the property, he discovered outcrops of quartz and considerable quantities of feldspar. The first feldspar quarry was opened in 1875. Kinkel's quarry and mill were a thriving center of the economy of the village of Bedford through the turn of the century. Several thousand tons of feldspar were taken from this quarry annually. The Kinkel quarry employed more than 100 men. Bags of powdered feldspar were taken to Bedford Station by carts pulled by draft horses until c. 1918, when motorcars made this transfer much easier. The outstanding quality of the feldspar found in Bedford was that it was pure white. It was nicknamed "Lenox Spar" because it was used by the Lenox factory in Trenton, New Jersey. In 1918, Lenox made the official White House china for Woodrow Wilson from the Bedford feldspar. This was the first White House china made in America. Corning Glass also used Bedford feldspar. Because the demand for Bedford feldspar was so large, local farmers began harvesting their own outcrops. Many locals sold feldspar to the J.T. Robertson Soap Company in Manchester, Connecticut, to make a scouring soap called Bon Ami. The site of the former Bedford Mining Company owned by Kinkel is located southeast of the village of Bedford off Middle Patent Road and Quarry Lane. A marker was placed on the site in 1991. There were other feldspar quarries in Bedford as well. One located on Baylis Lane and one on the Post Road near Reynolds Lane were the most productive. There was also a large quarry in the Mianus River Gorge. Production began to decline in the Bedford quarries c. 1936–1937 due to cheaper mining operations, mostly in Canada. The entire operation of the Bedford Mining Company finally closed in 1958.

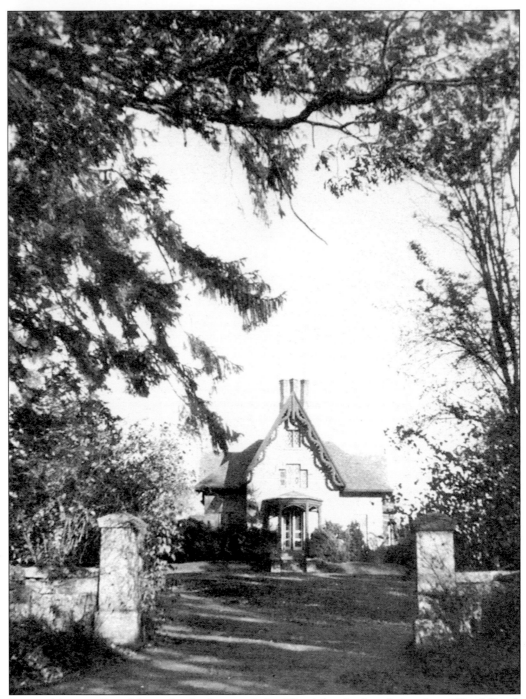

Pictured here is Brambleworth, the home of the Wood family. It is located on Wood Road, which leads to Bedford Hills. It was built in 1870 in a style popular after the Civil War. Brambleworth remains in the family today.

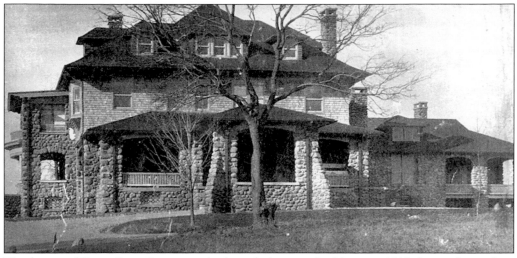

The home of Percy Pines Lewis was built and photographed here in 1910. It was located on Route 121 opposite Seminary Road. The property originally included gardens, a greenhouse, and various farming outbuildings. It was sited on the hill overlooking the hamlet of Bedford Village with views to Katonah and the hills of Mount Kisco. A fire destroyed the fine home in the 1940s.

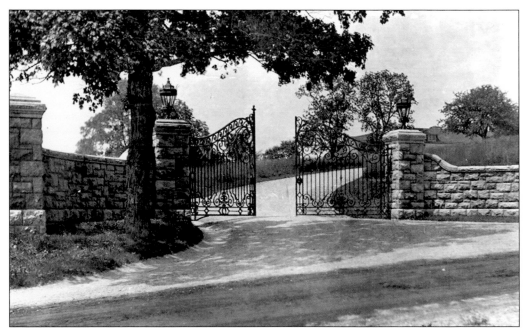

All that remains of the grand Lewis estate are these gates, which can still be seen along Route 121.

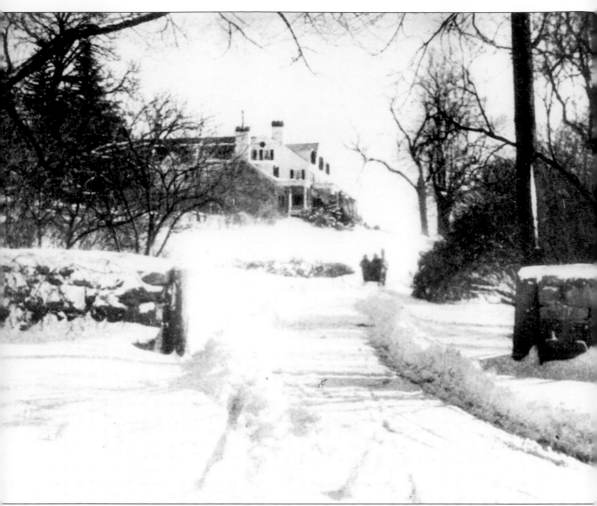

Born Eleanor Jay in 1882 and the daughter of William Jay II, Eleanor married a New York banker named Arthur Iselin and moved into this grand house. Eleanor and Arthur inherited Bedford House (the John Jay Homestead) from William Jay in 1915 and made it their permanent home. Their early house, pictured here, burned in a fire.

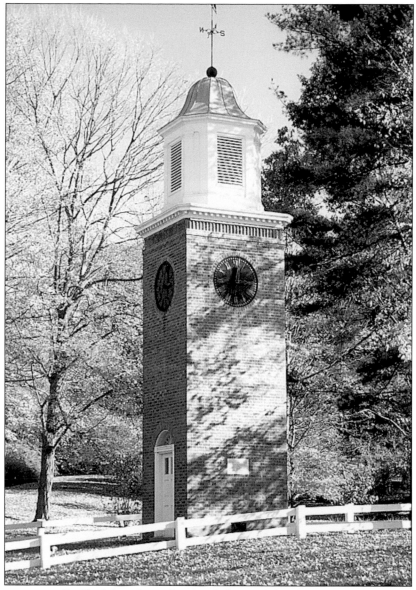

James Sutton was a Bedford farm boy who decided to seek his fortune in the city. He married the only child of R.H. Macy and joined a higher level of society. He partnered with Thomas E. Kirby to start the American Art Association, which handled the best art of its day. He left the firm in 1895 and retired to Bedford. To please his wife, who missed New York and the tower of Grace Church, he had a barn constructed with a cupola and tremendous clock from E. Howard Clock Company of Boston, Massachusetts. The barn burned down, but the clock, shown here, was donated to the town in 1939 and was built into this clock tower at Sutton Corners. The tower project was organized by a group of neighbors and is now maintained by the Clockwinders. The Sutton house on Guard Hill Road in Bedford was painted dark red with green trim. (It exists today but is white.) The grounds were landscaped by F.L. Olmsted. The house interior was made with marvelous woodwork and molding to showcase the collection of Monet and Manet paintings. The property also had a bowling alley, a large greenhouse, and a blacksmith shop.

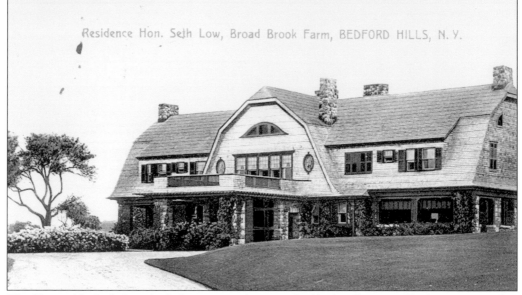

Residence Hon. Seth Low, Broad Brook Farm, BEDFORD HILLS, N.Y.

The Honorable Seth Low built his summer home in Bedford Hills on Bedford Center Road at the turn of the century. Dr. Low served as a longtime president of Columbia University and a one-time mayor of New York City. He was committed to social reform and uniting communities. Low worked with his fellow residents of Bedford Station to improve the hamlet. With William B. Adams, he urged the change of the hamlet's name to Bedford Hills, which rejuvenated pride among residents. This postcard of Low's home was published by W.B. Adams & Sons.

KENNETH M. MURCHISON
ARCHITECT
320 FIFTH AVENUE, CORNER OF 32D STREET
NEW YORK

TELEPHONE 4740 MADISON SQ. September 8th, 1905.

ARCHITECT'S STATEMENT OF COST

House for Mrs. Thomas E. Kirby, Mt. Kisco, N.Y.

GENERAL CONTRACT:	Geor. Mertz's Sons	$17413.00	
	Additions	887.54	18,300.54
EXCAVATION:	Uriah Dingee	1871.00	
	Additions	587.00	2,458.80
PLUMBING & HEATING:	G. E. Ganun	3225.77	
	Additions	731.67	3,957.44
SCREENS:	Higgin Mfg. Co.		360.00
RANGES:	Richardson & Boynton Co.		73.00
WATER SUPPLY:	W. A. Corcoran	1643.72	
	Additions	244.39	1,888.11
RAM:	Power Specialty Co.		150.00
ELECTRIC WIRING:	Feet, McAnerney & Powers	687.00	
	Additions	268.00	955.00
POWER HOUSE:	Dakin & Son		500.00
MANTELS:	White, Potter & Paige Mfg. Co.		110.00
ELECTRIC FIXTURES:	Black & Boyd Mfg. Co.		648.73
ARCHITECT'S COMMISSION:	At 5%	1470.08	
	Travelling Expenses	76.90	1,546.98
	Total Cost		$30,948.60

Tanrackin Farm is the family homestead of Wilhelmine Waller. It stands over many acres of open farmland along Guard Hill Road and reflects the grace of the gilded age in Bedford history. It was built for Waller's grandmother, Mrs. Thomas E. Kirby, in 1905. The building invoice on Tanrackin Farm shows that the total building cost was $30,948.60. The area contractors working on the home are also listed. The house can be seen on page 119.

74

The 1757 Maple Grove Farm survived the revolutionary destruction of Bedford Village. It is located on the Old Post Road north of the village and was built by revolutionary militiaman James Williams. A descendant of James was Francis Asbury Palmer, who purchased the family homestead and 500-acre working farm in the 1860s. Francis Palmer was the president of Broadway Bank in New York City. He was a business associate of "Boss" Tweed of Tammany Hall fame. He was a generous man and gave the largest donation to the state of New York to pay expenses of the Civil War soldiers. Also, Francis Palmer donated the funds needed to build the Bedford Presbyterian Church in Bedford Village. Palmer Lewis, a descendant of Francis, brought the first telephone system to town. A dozen families were connected to the Bell lines. The first indoor bathroom in town was placed in Maple Grove, according to old family diaries. Over time, the acreage decreased, but Maple Grove remains one of the town's few working farms today. The last of the Lewis family to own Maple Grove was Palma Hope Lewis Bedell. Upon her death, a collection of Native American artifacts and many family items were donated to the Bedford Historical Society.

Residents worked together to collect ice for the summer months. The processes of cutting and collecting ice and building icehouses to preserve the blocks throughout the summer were jobs shared by neighbors together. Ice was often the subject of many meetings of the Farmer's Club. Once New York City built reservoirs, a new source of ice became available. This early 1900s photograph shows farmers collecting ice on the Cross River Reservoir.

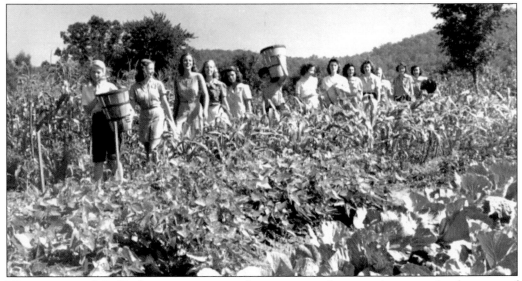

The women of Bedford were an extraordinary group of nature lovers and advocates of conservation. They founded many organizations in town to coordinate their efforts. Among other civic organizations, the three garden clubs in Bedford are examples of their interest in nature. The Bedford Garden Club, founded in 1911, was one of the first members of the Garden Club of America. The Rusticus Club was founded in 1939 to stimulate interest in and promote knowledge of gardening and the development of civic projects among its members. One requirement of this club is that members must actually do the work in their gardens. Rusticus is also a member of the Garden Club of America. A third club was more recently formed and took its name from the native hop plants found by our settlers. The Hopp Ground Garden Club is a member of the Federation of Garden Clubs of New York State. (Courtesy Bedford Garden Club.)

The beautiful stone fences meandering throughout town are the ruins of Bedford's agricultural past. Throughout the 19th century, 75 percent of the land was cleared and divided by stone fences into fields sometimes as small as an acre. Now only 15 to 20 percent of the land is cleared, with the remaining covered by second-growth forest and housing. Most of these fences were built as single walls. They looked "tossed" or stacked on the boundary of the fields. They were always dry walls with strategically placed alternating stone, usually about two to four feet high following the grade of the land. These fences had capping stones weighing 100 pounds each. One well-known field-fence maker of the day was John Mathews of Mount Kisco. "Waller John" trained crews that worked on the fences around town in the early 1800s. John Mathews was recognized by James Wood in the 1917 *History of Westchester* as a man with great skill. Wet walls were invented when farming died out. The introduction by a new influx of homeowners began creating estate walls. Today's new walls are marked by stone chiseled to a straight edge. They are laid for perfection and show more attention to boundaries rather than fields. The earlier stone fences are icons of a past era and give our landscape a strong sense of scale and history. (Courtesy Ward Pound Ridge Reservation.)

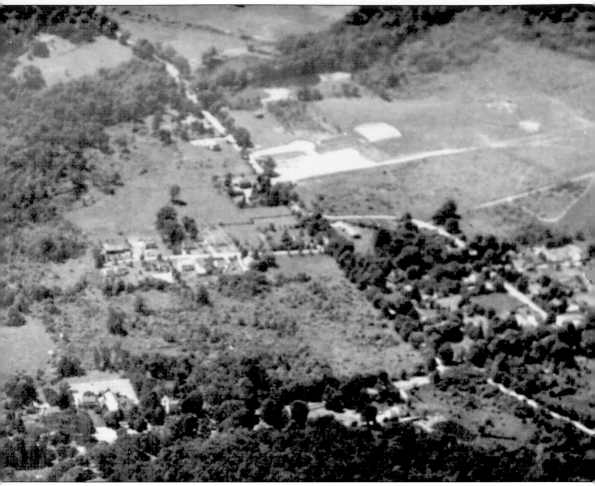

The airfield in Bedford was founded on an old cornfield by Mr. LeRow in 1929 and was used for private flying and entertainment. LeRow Airport was located where the Bedford Memorial Field is today. Every Sunday, residents could watch biplane exhibitions and even participate in parachute jumping. The airport finally closed in 1938. The top portion of this aerial photograph shows the land where the LeRow field was. The bottom right portion shows the beginning of the Farms.

Seven

FOUNDATIONS

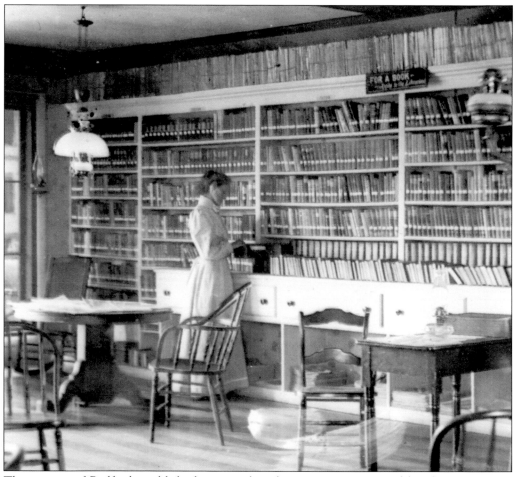

The citizens of Bedford established, nurtured, and in turn were nurtured by, the institutions pictured on the following pages. Churches, schools, and buildings recalling historical ties to New York, New England, and the nation have all played important roles in shaping the character of Bedford. The following photographs illustrate some of these foundations. Other related photographs have appeared in the preceding chapters on the three hamlets of Bedford, or will appear in the concluding chapter entitled Outdoor Life. All of them help to define the people we are and the town we call home. Shown here is an early volunteer at the newly established Katonah Reading Room and Library. (Courtesy Katonah Historical Museum.)

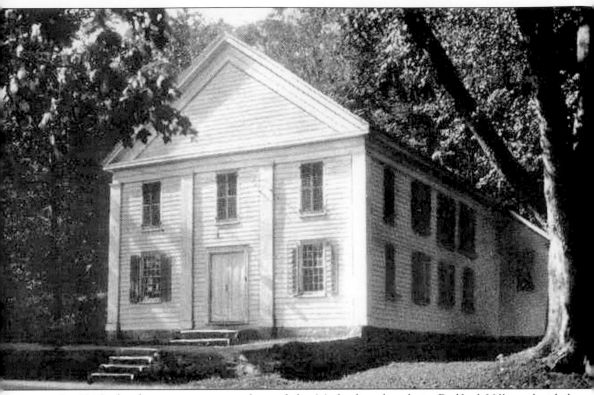

In 1916, the few remaining members of the Methodist church in Bedford Village decided they could no longer support their church and decided to sell the building. It went for public auction and was most likely going to be turned into a rooming house. Recognizing the historic significance of this building, Col. Thatcher Luquer and a group of colleagues purchased it to be used as a meeting place in town. This is now Historical Hall, and this group became the founding members of the Bedford Historical Society. The society continues the pursuit of historic preservation and education.

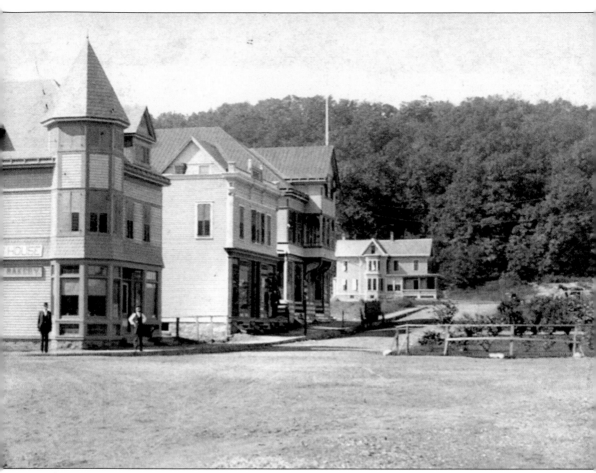

The Katonah Village Improvement Association was organized in 1878 with Henry E. Pellew as its first president. Part of a public movement to better communities that was popular in New England, it is among the oldest improvement societies in the country and one of the few still in existence today. One of the Katonah Village Improvement Association's purposes was to open a reading room and library. It began with a large collection of 400 volumes. The association orchestrated planting ornamental trees and street lamps in old Katonah. Public lectures were organized, and education was encouraged in sanitary reform. When New York City required the building of the Croton Reservoir, thus flooding old Katonah, an inspired Katonah Village Improvement Association, under the leadership of Clarence Whitman and William H. Robertson, organized the layout and move of the village to its new location in 1896 and 1897. Today, the association remains a valuable member of the community, striving to maintain hamlet vitality while preserving history and encouraging wise growth. This early photograph shows a brand-new Katonah in 1899. The street is the Parkway.

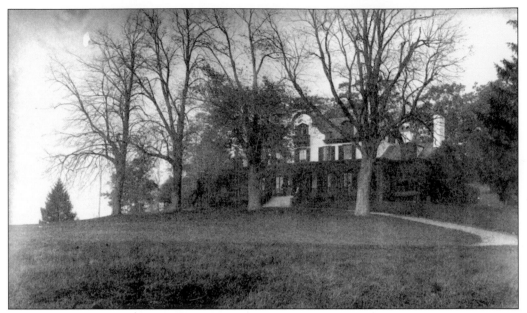

Upon retirement from an active political life, John Jay returned to his family homestead, Bedford House, on Cantitoe Street. Renovations and enlargement of the home began in 1801. Realizing the historic significance of this house, Westchester County purchased it in 1958 from Jay descendants. It was given by the county to New York State to renovate and use as an operating museum. It is now known as the John Jay Homestead and contains much of its original furniture and a wonderful collection of American portraits. The photograph above, taken c. 1850, reflects the lavish renovation by the Jay family. Below is how the building looks today, renovated by the state government to appear as it did in 1801.

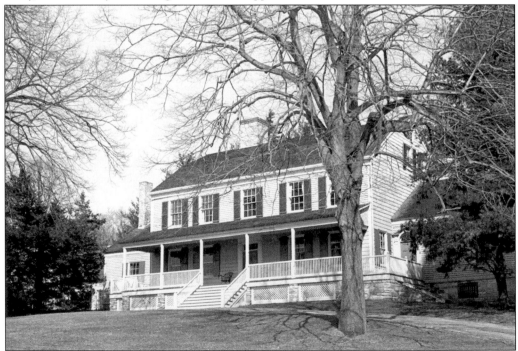

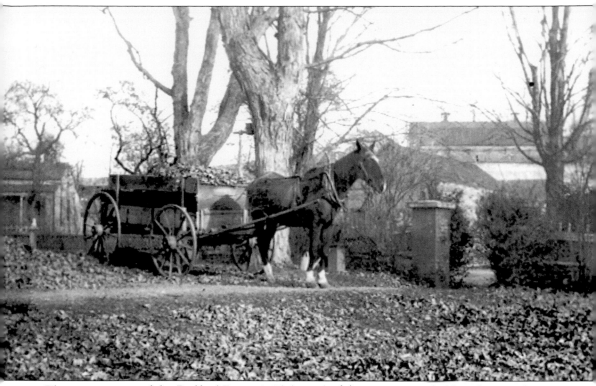

The organization of the Bedford Farmer's Club resulted from a meeting held in the courthouse in 1851. The meeting was called and presided over by Judge William Jay. The group heard a lecture on the cultivation of fruit by Dr. R.T. Underhill, who had a successful orchard and shipped apples to the London market. These gathered farmers all decided that they needed more science and information in their agriculture and horticulture. The first official meeting was held in Warren Collier's Hall in Katonah in February 1852, and the first president was Arnell Frost Dickenson. Dickenson was also superintendent of the poor of Westchester County and began a major reform of registering children living in almshouses to prevent them from being taken for unpaid farm labor. He also introduced legislation to prohibit animals from running at large on the highways of Westchester County.

Another founding member was James Wood (also elected town supervisor). He made monthly reports of the Bedford Farmer's Club to the Department of Agriculture in Washington, giving the detailed methods of cultivation of various crops and products in this vicinity. Wood had a brilliant mind and imparted his knowledge frequently to members of the club. He was a practical man and stressed the importance of healthy living and eating. Charter members were Rev. Lea Luquer, William Sanders, John Holmes, Henry Marquand, Oliver Green, and others totaling 23. Women were finally admitted as club members in 1901.

The Farmer's Club allowed area farmers to band together. Mr. Jay and Mr. Wood negotiated with Mr. Vanderbilt, president of the New York Central and Hudson River Railroad, to reduce freight tariff of products from Bedford's farms to New York City in order to compete with goods from Pennsylvania and Ohio. They also banded together against the most disliked middleman of the time, the milkman. They forced legislation controlling the milkman's markup of milk and also ending his practice of watering down the milk before it reached the market. Other critical farming issues, from public education to building the best icehouse, were addressed.

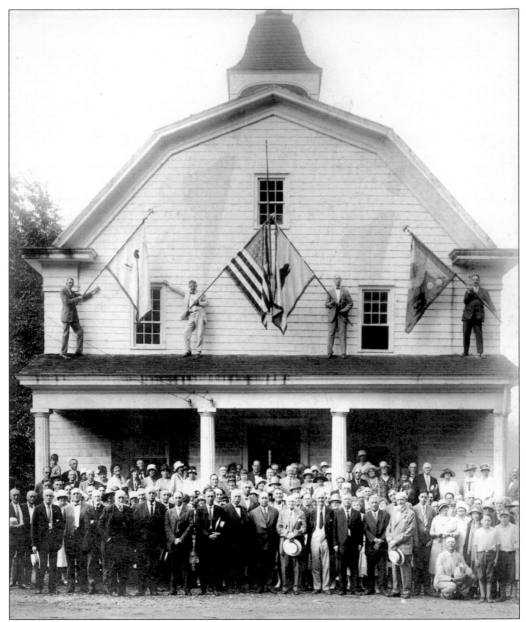

This is a photograph of the Bedford Farmer's Club taken in April 1927 for its 75th anniversary. Members stand in front of the Bedford Courthouse. Complete minutes from the club have been kept and saved since 1867. Today, the Bedford Farmer's Club opens each meeting with a reading by member Elizabeth Levin. The president today is James Wood, grandson of founding member James Wood. Issues discussed are very different and include, among other topics, pesticide use and the over-population of SUVs on our fragile country roads. Membership peaked in 1950, with 250 members and a two-year waiting list to become involved. Today, membership has dwindled, but the commitment to farming issues and preservation of open space and natural resources is as active as ever.

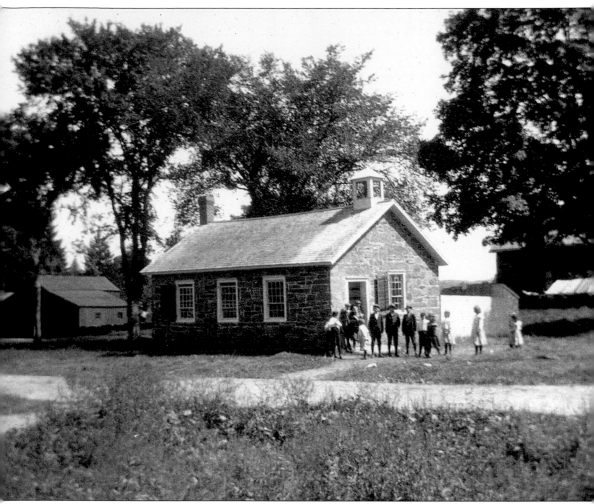

During the 18th century, a number of private neighborhood schools were founded to teach Bedford's children. By 1813, the town voted to comply with the state law providing for a common school system. At that time, there were 14 school districts established (actually only 13 but no one wanted to be burdened with an unlucky District 13). By 1867, the districts grew to 15. These were one-room, neighborhood schools that were open year-round, but attendance fluctuated with the seasons. The costs of public education were split in those days. The town's share provided for building, repair, and maintenance of all schoolhouses. The parents of attending children paid all the costs of tuition. The critical requirement in hiring teachers was moral character. Scholastic requirement was not uniform. By the late 1800s, these 15 school districts merged into larger ones in the interest of economy. The Union Free School District developed, sponsoring a study in 1950 to make recommendations for the future of education in Bedford. A large high school was built in 1956 to serve the Mount Kisco, Bedford Village, and Pound Ridge areas. A second high school, also completed in 1956, folded Katonah into school districts to the north. Most of the buildings that served as district schools have either been demolished or converted to private use. The last of these little district schools continued in operation until 1973. One of the most recognized district schools is the Stone Jug School located in Bedford Village on the green. It was built in 1829 and was used as a village school until 1912. This photograph shows the school as it stood on January 1, 1906. Another early image can be seen on page 20.

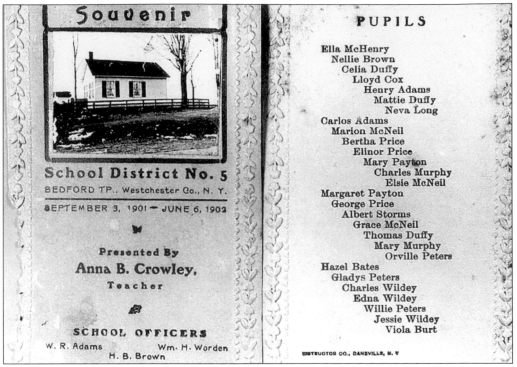

This postcard was given to the pupils of School District No. 5 by their teacher, Anna B. Crowley, in 1902. The school no longer exists but was on the corner of Broad Brook and Succabone. Note that Lloyd Cox, father of Lloyd Bedford Cox Jr., director emeritus of the Bedford Historical Society, is listed among the students.

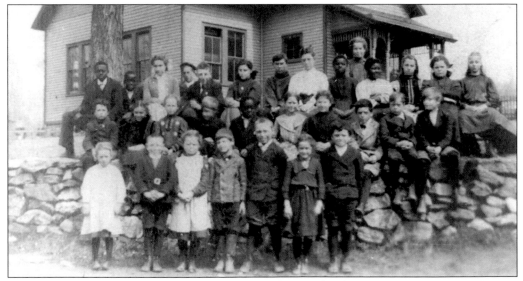

The children of District 14 pose proudly in front of their school, located on the corner of Harris and Bedford Center Roads. The school is now a private residence. Some of the students seen here are Louis Harrison, Virginia Woodcock, Vivian Waite, Anna Harrison, Albert Storms, Gertrude Harrison, the two Woodcock boys, Len Brown (the father of current Bedford residents David F. and Earl Brown), Theodore Peterson, William Harrison, and Alice Harrison.

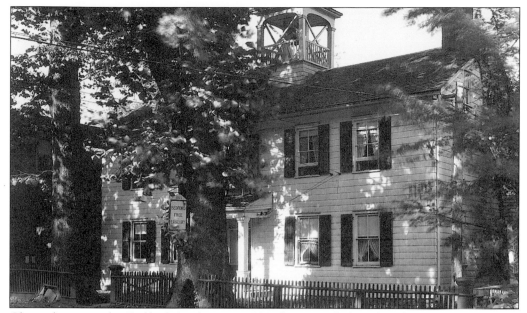

Classes began at the Bedford Academy in 1809, five years before the adoption of a common school system in New York. The academy, chartered by regents of the University of the State of New York and built on land donated by the Presbyterian Church Society, was a nondenominational institution. It served the community until 1902, teaching an impressive list of students including John McCloskey, the first American cardinal of the Roman Catholic Church; Gen. James W. Husted, for many years speaker of the assembly; William H. Vanderbilt of the railroad family; Maj. Gen. Phil Kearny; and John Jay II, grandson of the first chief justice. The academy, pictured here, is now the Bedford Free Library.

The Bedford-Rippowam School was founded as a private school for girls in 1917. It merged with the Conover School for boys located on Stone Hill Road. It was chartered by the New York State Board of Regents in 1930. In 1935, the school absorbed the New Castle School of Mount Kisco and most recently, the Cisqua School. In the early days, it had been a boarding school but, since 1955, has only day students. This photograph depicts the Van Rensselaer house, the first home of the Rippowam School.

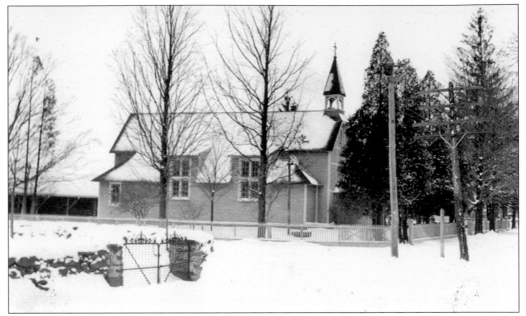

The first St. Patrick's Church of Bedford Village, seen here, was on the corner of Greenwich Road and Route 22. As the parish grew, members of St. Patrick's collected money for the erection of the present church (1928) on land given by Thomas O'Brien. The architect was William Edgar Shepherd Jr., who also designed the Bedford Village firehouse. St. Patrick's stands on the south side of the village green.

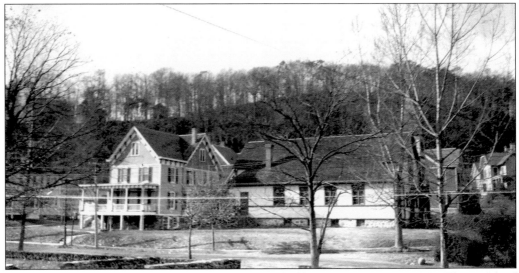

The first Roman Catholic services of the area were held in Mount Kisco in 1861. The parish of St. Francis of Assisi was established in 1871. With the change of parish boundaries, St. Mary's of the Assumption Roman Catholic Church was erected in 1890 in old Katonah. It was moved to its present site on Valley Road in 1899. This photograph shows the church and rectory of St. Mary's shortly after it was moved to its new site as an anchor of new Katonah. The Catholic members of Bedford Station first held services in the Fireman's Hall. Funds were raised, made up of gifts from all community members, and land was donated by the Snyder family in order to build the Church of St. Matthias.

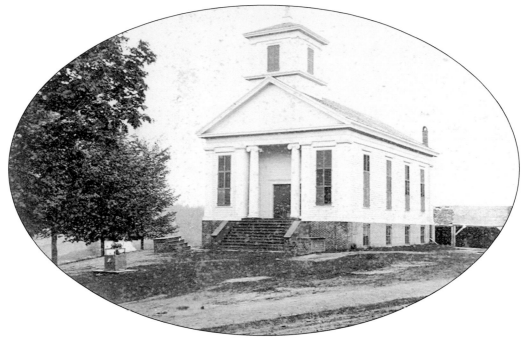

Shown here c. 1867 is the old Baptist church, which stood in the triangle at the junction of Route 22 and the road to Bedford Hills. It was founded in 1787 by 17 members of the Baptist church of Stamford. The church has been torn down, and the site is marked today by a granite cross. The church rectory across the street still exists and is a private residence. Its sister church on Route 121 in Cross River functions as a church today.

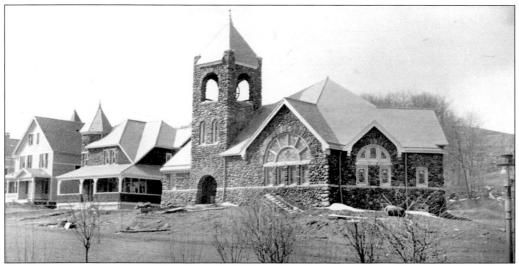

The congregation of the Katonah Methodist Episcopal Church had its early origins in Whitlockville in 1836. The building of the church was dedicated in 1837. As members of the congregation moved their homes and businesses closer to the new railroad station in old Katonah, a new church was built in 1874. With the condemning of old Katonah for the new reservoir, the Katonah Methodist church again was on the move, and in 1899, ground was broken for the new stone structure where it stands today on the corner of Edgemont and Bedford Roads.

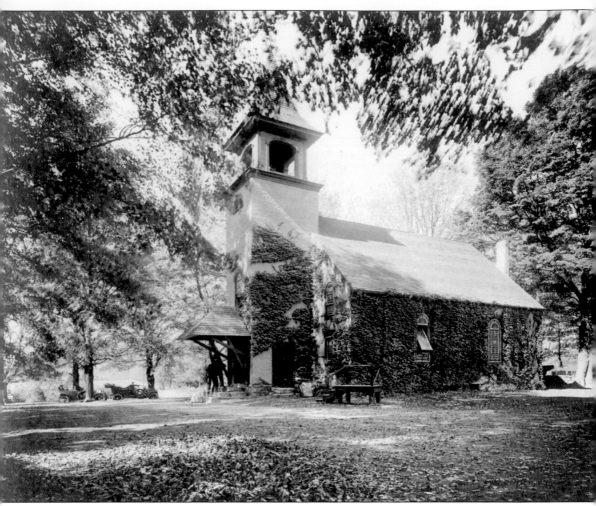

In 1693, missionaries from Rye urged that Church of England services be held in Bedford. A wealthy Englishman, St. George Talbot, took this missionary push to establish a church just over the Bedford line of North Castle. The church was called St. George's, but the conclusion was quickly drawn that it would be better to have a church in Bedford Village. A search was launched for appropriate land to build the new church. With money donated by John Jay, land was purchased in 1803. The historic brick church building was completed in 1809 and dedicated on October 17, 1810. William Miller, David Olmstead, and Peter Jay constituted the building committee. Early vestrymen included David and Nicholas Haight, Samuel Miller, and John Whitlock. A number of families, notably the Jays, gave prominence to St. Matthew's. The church's first rector was Rev. Samuel Nichols. A later rector who came to St. Matthew's in 1866 and made a lifelong commitment to the town of Bedford was Rev. Lea Luquer. Reverend Luquer remained for 53 years, and his kindness extended far beyond the St. Matthew's parish. His contribution, along with those of his children, is further summarized in Chapter Eight. This photograph of St. Matthew's was taken in the early 1900s. Note the early automobiles arriving for services. Many members still rode on horseback or in buggies through the 1950s. Wilhelmine Waller recalls that the last time her family rode on horseback to church was in 1977. They finally stopped because the horse shed, located in the middle circle, was too small and in such disrepair. Both St. Matthew's Church and the churchyard cemetery are listed on the National Register of Historic Places.

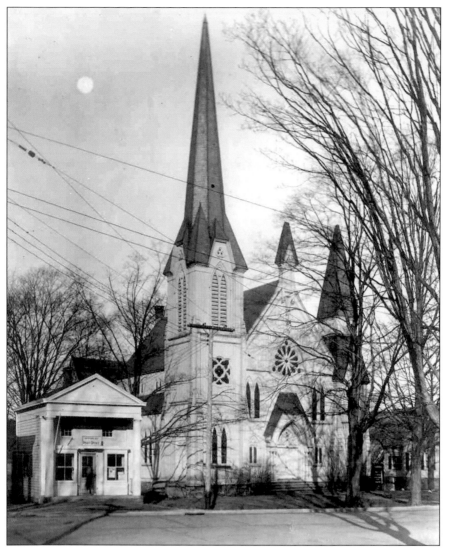

The Bedford Presbyterian Church that so elegantly looks over the village today is actually the fourth Presbyterian church built in Bedford. The first minister to settle here in 1684 was Rev. Thomas Denham. He is buried in the Old Burying Ground under Bates Hill, although his stone cannot be seen today. Records show that the first meetinghouse, as the church was called in early days, was built in 1689 at the site of today's Historical Hall. In 1700, Bedford came under the government of New York, and this church was transferred to the Anglican parish of Rye, New York. Numerous confrontations followed between the rule of England and the people of Bedford, who feared that they would lose their religious rights. Despite numerous negotiations, Bedford remained part of the Anglican Church until the Revolution. The second meetinghouse was built up the road as a concession to the northern settlement of the town. It was located at the current intersection of Route 121 and Route 22. It was burned by the British on July 11, 1779, along with most other buildings in the village. The third house of worship was built on a plot of land given by Capt. Lewis McDonald. It was dismantled and now is located at Westmoreland Sanctuary. The fourth Presbyterian church (the current Gothic Revival structure we see today) was completed in 1872 with funds donated by Francis A. Palmer. As part of his donation, Palmer stipulated that all pews were to remain free so that anyone could choose to worship there.

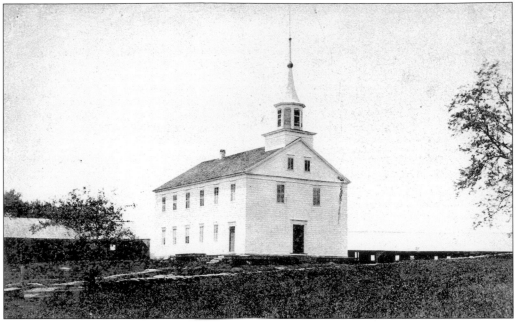

This 1860s photograph shows the third Presbyterian meetinghouse. It was built in 1783 and replaced in 1872. It was moved and now is located at Westmoreland Sanctuary.

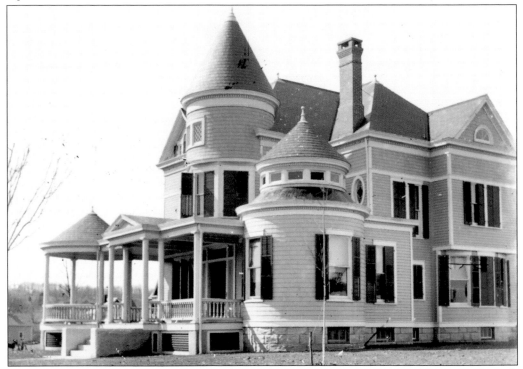

In 1917, two residents of Katonah started the Christian Science Society and became a branch of the First Church of Christ Scientist. They met in several locations until they purchased their own building in 1950, the retirement home of Judge William H. Robertson, on the corner of Bedford Road and the Parkway. (Courtesy Katonah Historical Museum.)

Although a relatively peaceful town, Bedford at the turn of the century had a number of incidents that led to the formation of a permanent police department. The 1896 burglary and murder at the Adams store in Bedford Station and a number of arson cases in Bedford Village prompted the formation of a police department in 1909. It consisted of Chief Eugene S. Fee and three patrolmen. In this 1909 photograph, which hangs above Chief Newman's desk today, the patrolmen, from left to right, are Patrick Towey, John Scheisser, Eugene Fee, Thomas Wade, Julius Englehardt, and James Russell. (Courtesy Bedford Fire Department.)

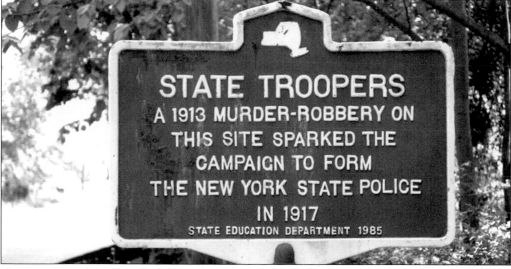

The founding of the New York State Police in 1917 was the direct result of a murder in Bedford four years earlier. Moyca Newell and Katherine Mayo were having a home built on West Patent Road when, one Saturday morning, the contractor's foreman was murdered for the payroll. The lack of cooperation in seeking the murderers so angered these ladies that they modeled a plan for New York after the newly formed Pennsylvania State Police Department. They took this plan to the New York State Legislature, and as a result, the New York State troopers were formed. Although the plaque stands on West Patent Road, the murder actually took place near the corner of Guard Hill and West Patent Roads.

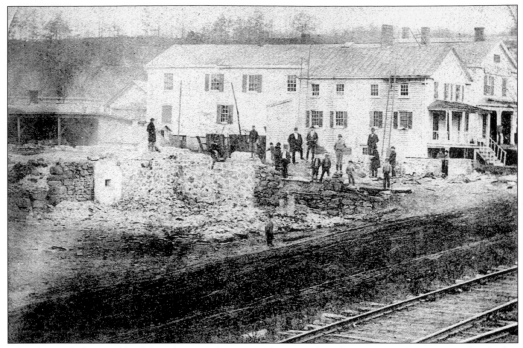

The first of the Bedford hamlets to form a volunteer fire department was Katonah. A fire broke out in old Katonah in 1874 with no way to fight the flames except neighbors' household buckets. Funds were collected for a hand-pumper truck. In fact, three companies were formed and consolidated into the Katonah Fire Department in 1899. F.S. Folsom gives us the image above, which shows Katonah after this great fire.

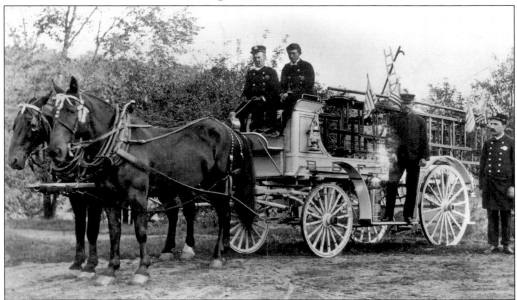

Bedford Station organized its fire department on February 4, 1903, with 27 volunteer members. At that time, its equipment consisted of only four buckets. In 1906, the department purchased its first piece of professional equipment, seen here. The Bedford Hills Fire Department celebrated its centennial with a grand parade on May 17, 2003.

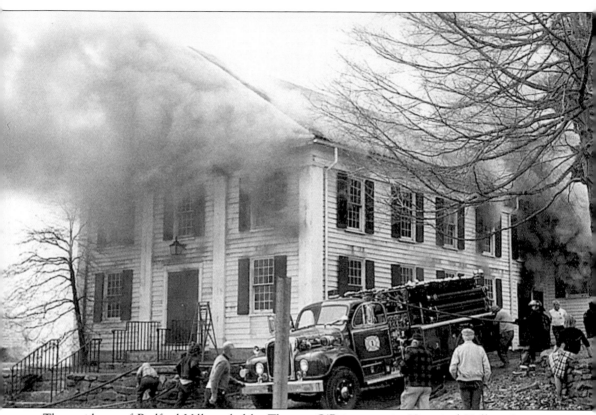

The residents of Bedford Village, led by Thomas O'Brien, met in Historical Hall on January 8, 1923, to discuss the problem of fire protection. Bedford Hills had offered to make two tanks available if a new Bedford group was formed. Twenty-seven members of the community stepped forward to serve. The firemen built a temporary firehouse behind the A & P. It was formally incorporated under the name of Bedford Fire Company No. 1 on January 6, 1927. Two months later, the first piece of equipment was purchased, a Seagrave fire truck. In 1929, plans began for a new firehouse. It was completed in 1930 and continues to serve the village today. This photograph shows the Bedford Village Volunteer Fire Department saving Historical Hall from the 1976 fire.

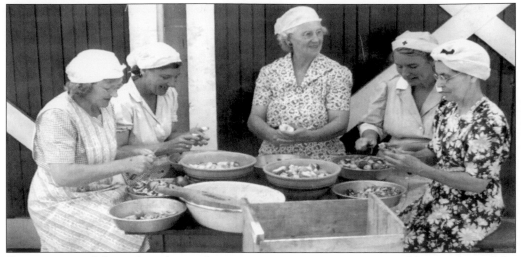

Canning, one of the earliest forms of conservation in town, was organized by members of the Bedford Garden Club to store food during times of plenty to meet future demands of local schools, hospitals, and other institutions. All excess food was donated and canned. Originally organized during World War I, this canned food relieved shortages in town caused by war conditions. During World War II, under the name of Victory Gardens Cannery, Mrs. George M. Schurman and Mrs. James L. Harrison organized many Bedford, Bedford Hills, Katonah, and Mount Kisco women to operate the cannery in a large barn owned by Eldon Bisbee and located on the Bedford Center Road. Each village picked a weekday when its women volunteered as canners. The vegetables and fruit came from local farms and estates. These canned goods were made available to local schools and hospitals in order to free up commercially canned food for the troops. Here we see Bedford volunteers at work. (Courtesy Bedford Garden Club.)

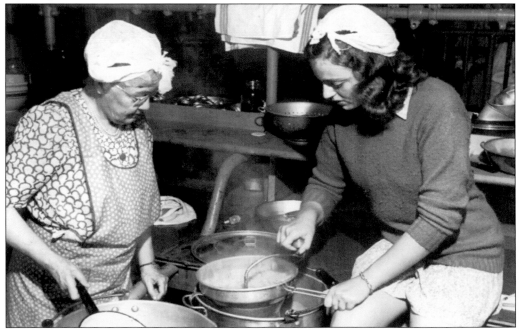

Mrs. Paul Clymer and her granddaughter Polly Harrison (the future Mrs. Walter Winans) work in the Bedford Hills cannery of Victory Gardens. (Courtesy Bedford Garden Club.)

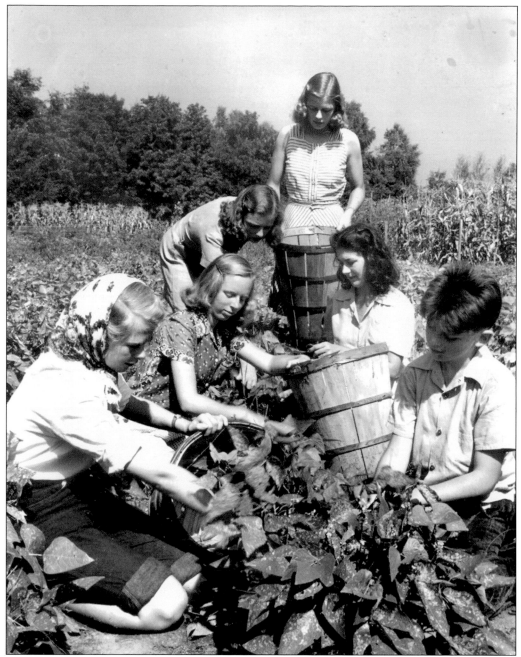

Even young girls were encouraged to help with the canning effort. Seen in this photograph are young Denny Ward (second from the left), Polly Harrison (third from the left), and Milly Harrison (standing in the center). More than 700 women and children worked in the cannery and in the fields collecting fruit and vegetables during Victory Gardens's years of operation. They were recruited through parent-teacher associations, the Women's Auxiliary of the Northern Westchester Hospital, and the Red Cross canteen. (Courtesy Bedford Garden Club.)

The town of Bedford was the birthplace of the District Nursing Association. The organization is dedicated to providing nursing services in rural areas and was inspired by the work and dream of Ellen Wood. Determined to help her neighbors when medical attention was difficult to find, Ellen decided to go to nursing school. In 1898, she convinced a group of Red Cross volunteers in Bedford to organize a nursing association. Ellen died shortly after from the fever, but the association has continued in her memory. In those days, a nurse would make her rounds on a borrowed horse and buggy, attending to the county's needy as best she could. It was 30 years before there were funds available to pay salaries to these dedicated nurses. In 1941, the District Nursing Association of the Bedford area consisted of 10 nurses and 10 motorcars. Mrs. Henry Marquand brought Ellen's idea to fruition. She is seen here.

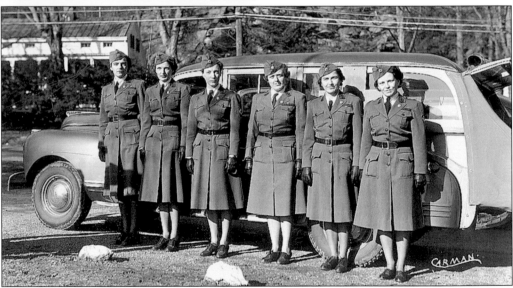

Auxiliaries of the American Red Cross formed all over the country in the late 1890s. Mrs. Henry Marquand formed Auxiliary No. 20, which covered northern Westchester, in 1898. Initial members of the organization included Mrs. William Jay, Mrs. Clarence Whitman, Mrs. James Lounsbery, and Mrs. William Robertson. No. 20 became active during both World Wars. The ladies of the American Red Cross gave home health services, disaster relief, canteen supplies, local blood bank help, and courses in home first aid. Pictured here, from left to right, are Private Hitchcock of Mount Kisco, Private Riegel of Bedford, Sergeant Wilcos of Mount Kisco, Lieutenant Sherwin of Mount Kisco, Corporal Rogers of Pound Ridge, and Private Clark of Pound Ridge.

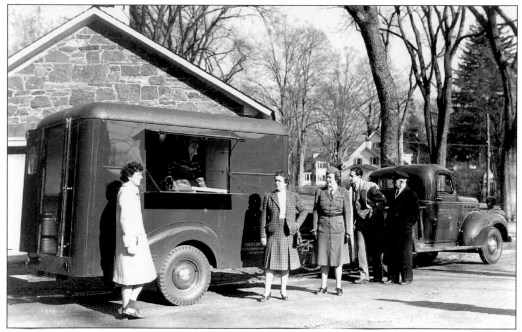

During World War II, the American Red Cross Auxiliary No. 20 traveled throughout northern Westchester supplying the community with needed nutrition. Food and supplies were collected and distributed as needed. This photograph shows the canteen set up in front of the schoolhouse in Bedford Village on the south side of the green.

In 1939, Walter and Lucie Rosen completed their grand house on Girdle Ridge Road. No expense was spared in the creation of baroque-styled rooms like those found in Europe at the time. Music was a focus of their life in Bedford. Walter Rosen was a founder of the Friends of Music in Westchester and built a music room in his house to seat several hundred people. Caramoor was endowed by the Walter and Lucie Rosen Foundation and serves as a center for classical music today.

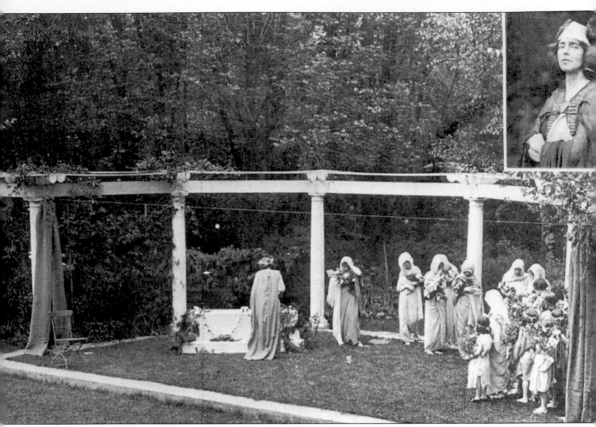

In the summer of 1900, Martia Leonard persuaded her family to give her the deserted, run-down house and garden on family land along South Bedford Road. It was to be transformed into a blooming garden and stage for an all-American theater. Leonard felt that the nation's interest in foreign theater and ballet did not allow for the development of American talent. She felt that Americans could act, speak, sing, and dance as well as the Italians, French, or Germans. Her commitment led to an opportunity for American dramatic art. Her stage was called the Brookside Theatre. The first production was *The Treason and Death of Benedict Arnold*. Brookside continued as a highly regarded open-air theater for nearly 30 years. Since 1968, the original house, barn, and colonnade theater have provided headquarters for the Cornelia Van Rensselaer Marsh Nature Sanctuary. The columns of the theater can still be seen today along Route 172 next to Leonard Park in Mount Kisco. Pictured here is a live performance, with Leonard's photograph in the inset. (Courtesy Cornelia Marsh Sanctuary.)

Eight

LEGACIES

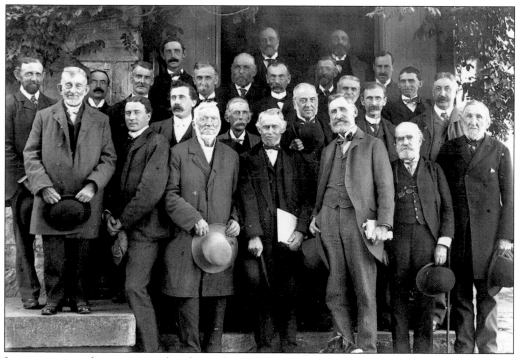

In every town there are people who make a difference, those individuals whose love of their homeland spurs them on to create organizations or engage in a life's work that adds to the character of their community. This chapter is dedicated to some of the people who helped shape Bedford and define its character. These are men and women who have followed a strong vision and left a legacy. They have been dedicated to their community and to their beliefs. Their accomplishments make us proud that they are from Bedford. But they are not the only ones to write about. We chose the following legacies but wish we had three times the number of pages to include other worthy and interesting residents. It is evident that another book could be devoted to these other residents, both past and present. Pictured here are members of the Bedford Farmer's Club in 1902.

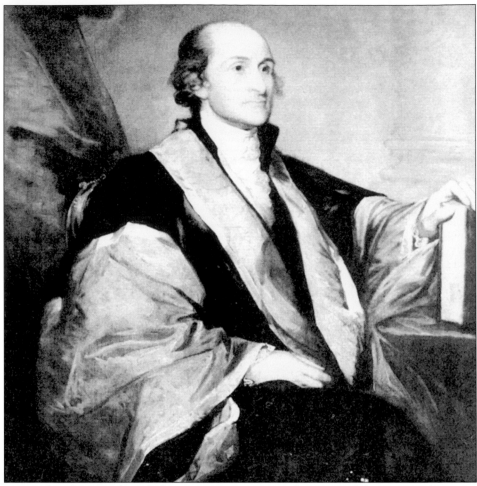

Statesman, legislator, author, diplomat, jurist, patriot, and governor, John Jay stands out as one of the towering figures of his age. Raised at the family farm in Rye, New York, Jay received a broad bilingual education available to the wealthy of the late 18th century. He obtained his Bachelor of Arts degree from Kings College (Columbia University) in 1764 and began his law studies just as the furor over the Stamp Act was igniting patriot sentiment. John Jay was quickly recognized as a pragmatist and constitutional thinker. He brought moderation and a trained legal mind to his commitments as a Revolutionary patriot. In his own words, "Not being of British descent I cannot be influenced by that tendency towards their national character, nor that partiality for it, which might otherwise be supposed to be so unnatural." John Jay served his new country for 27 years. He authored the New York State Constitution, served as president of the Continental Congress, and was minister to both France and Spain. He negotiated the Treaty of Paris in 1783, which gave the new nation the Northwest Territory and access to the Mississippi River. Had the British forts remained in the Ohio valley and the Spanish kept control of the Mississippi, our nation's history would have been far different. So great was George Washington's respect for Jay that he was offered any cabinet position he desired in the new government. Jay chose to be chief justice. He held more positions in government than any other founder and was twice elected governor of the state of New York. John Jay retired in 1801 to the country home that he and his wife, Sarah Livingston Jay, had built in Bedford on 800 acres of land inherited from his mother's apportionment of the Van Cortlandt estate. The John Jay Homestead remains as a Bedford landmark.

Growing up virtually next door to the John Jay Homestead, a very different but equally dedicated public servant emerged from Cantitoe Corners to serve Bedford. Born in 1823, barely six years before the passing of John Jay, young William Henry Robertson received his education at one of the newly established public schools and then at Bedford Academy. He studied law in the office of County Judge Robert S. Hart of Bedford. Bedford was a half-shire county seat for Westchester County, so Robertson gained first-hand knowledge of the practice of law in his own backyard. Robertson's mentor as a young lawyer was the great Henry Clay with whom he corresponded. Robertson was both a successful lawyer and political leader, taking on his first public position in 1845 as superintendent of schools. In his long political career, he served as town supervisor, state assemblyman, and state senator for numerous terms. In 1855, Robertson was elected to his first term as county judge of Westchester County, where he served for 12 years and gained the local nickname of "Old Judge Robertson." Judge Robertson entered national politics in 1860 as an elector to Abraham Lincoln. In 1866, he was elected to the House of Representatives, and by 1876, he was recognized as one of the more influential members of the Republican party. Robertson is given credit for breaking the deadlock in the 1880 Republican convention, which nominated James A. Garfield to be the standard bearer. Judge Robertson's home was always in the town of Bedford, and in his retirement he built and lived in a magnificent Victorian house in new Katonah, which is currently used as a place of worship by the First Church of Christ, Scientist.

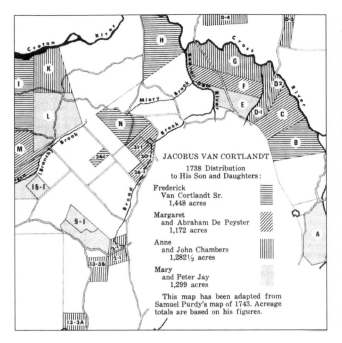

JACOBUS VAN CORTLANDT

1738 Distribution
to His Son and Daughters:

Frederick
Van Cortlandt Sr.
1,448 acres

Margaret
and Abraham De Peyster
1,172 acres

Anne
and John Chambers
1,282½ acres

Mary
and Peter Jay
1,299 acres

This map has been adapted from
Samuel Purdy's map of 1743. Acreage
totals are based on his figures.

Jacobus Van Cortlandt was born in 1658, the son of Oloff Stevense Van Cortlandt from Holland. His father was an important figure in New York City during the early Dutch government of the late 1600s. Jacobus was unlike other property owners of the day who acquired and sold land. He bought to hold and kept acquiring much land in Bedford. His first purchase was from John Dibell, and the tract was known as Cross's Vineyard. On this land, his grandson John Jay established his retirement home. Jacobus kept almost all of the Bedford land until 1738, when it was turned over and divided between his three daughters and one son.

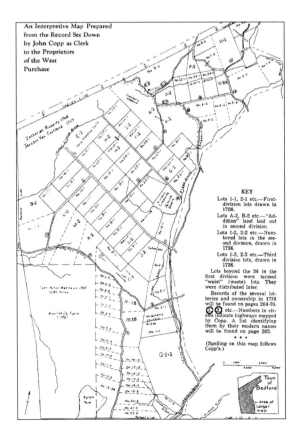

An Interpretive Map Prepared
from the Record Set Down
by John Copp as Clerk
to the Proprietors
of the West
Purchase

KEY

Lots 1-1, 2-1 etc.—First-division lots drawn in 1708.

Lots A-2, B-2 etc.—"Addition" land laid out in second division.

Lots 1-2, 2-2 etc.—Numbered lots in the second division, drawn in 1736.

Lots 1-3, 2-3 etc.—Third division lots, drawn in 1736.

Lots beyond the 36 in the first division were termed "waist" (waste) lots. They were distributed later.

Records of the several lotteries and ownership in 1738 will be found on pages 264-70.

① ② etc.—Numbers in circles indicate highways mapped by Copp. A list identifying them by their modern names will be found on page 263.

* * *

(Spelling on this map follows Copp's.)

Town
of
Bedford

area of larger map

John Copp was born in Boston in 1673 and received a New England education. In 1699, he migrated to Connecticut and the new town of Bedford. He was skilled as a surveyor and a writer. Both skills were sorely needed in the new town. This was the period of land acquisition, and Copp was immediately put to work. On November 14, 1699, the town granted him 23 acres of land "upon the condision yt he inhabits amon us three years." Copp agreed and was appointed to the committee to negotiate more land sales from the Native Americans. Within two months, he was made town treasurer and chief surveyor of lands. He laid out the lots of the newly acquired land and the highways of the new purchases.

The Luquer family came to Bedford in the summer of 1866. Rev. Lea Luquer was the rector of St. Matthew's Church for 53 years. He was a lawyer by training and drew upon his knowledge to help people with numerous legal issues. His wife was also devoted to community service, a trait that she passed on to their three children. The oldest son, Lea, was a professor of mineralogy at Columbia University. His research led to the knowledge and cataloging of the rock formations found in the Bedford area. The second child was Col. Thatcher Taylor Payne Luquer, seen here with his sister, Eloise. He was a civil engineer and a distinguished soldier in World War I. He worked tirelessly with the state authorities on proper road designations around town. It was Colonel Luquer who, along with a group of Bedford residents, mobilized to buy the Methodist church when its small congregation felt it could no longer support the large expenses. At the time, a developer wanted to convert the church into a tenement house. Colonel Luquer and the group purchased the property now known as Historical Hall. The group became the Bedford Historical Society, and Historical Hall was the first preservation effort.

Reverend Luquer's daughter, Eloise Payne Luquer, became known for her talents as a botanist and an artist on a national level. She loved to drive with her father on parish calls. This meant long trips over country roads at a speed of about four miles per hour. She used this time to study and admire wildflowers. She put her talents to capturing their beauty in watercolor. Over her lifetime, she painted more than 400 native wildflowers in Westchester County. She and her friend Delia Marble started a native-plant garden in the Ward Pound Ridge Reservation, which still exists and is maintained by the reservation and the Bedford Garden Club.

Contributions by the Wood family to Bedford were and continue to be significant. In the 1860s, Henry, John Jay, and James II (seen here) played prominent roles in farm organizations. Henry had been president of the Westchester County Agricultural Society. John Jay served as president of the Bedford Farmer's Club. James II served as town supervisor and designed the town seal. He was also instrumental in founding the Westchester County Historical Society and was its president from 1877 to 1900. Just like his brother John Jay, James II also served as president of the Bedford Farmer's Club.

Among the Woods to carry on this tremendous town service was James's daughter Ellen, who founded and organized the District Nursing Association. James's second daughter, Carolena, was keenly interested in women's suffrage and organized a large north county group aided by the League of Women Voters. James's son, Hollingsworth, finished his law degree at Columbia University and, with his friend Gustavus T. Kirby, organized the firm of Kirby and Wood in New York City. Hollingsworth's son James III, among many other accomplishments, is president of the Bedford Farmer's Club today. Seen here is Henry Wood.

The Dickinson family came to Cantitoe in 1773 to the farm now owned by Martha Stewart (and formerly owned by George and Ruth Sharp). Arnell F. Dickinson was a forward-thinking farmer and contributor to Bedford life. Born in 1818, he spent a lifetime committed to improving social conditions in the United States. He served on the board of directors of the Temperance Society. Dickinson also encouraged reform of almshouse records, specifically the records of the children who were sent out to work on farms throughout the country. Additionally, he was dedicated to public school education and ensured that local schools around Cantitoe were well equipped. Dickinson held many public offices in town, including the Bedford town supervisor office from 1849 to 1851. In 1852, he became the first president of the Bedford Farmer's Club. He was always interested in scientific farming and encouraged farming advancement nationally.

Knowing every inch of Bedford and its history, Elizabeth Nexson Barrett lived her entire 91 years in Katonah, where she served the town she loved through community service. Born in 1867, she is remembered as a one-woman welcome wagon to new families. Active in the District Nursing Association, the Red Cross, the Village Improvement Association, and the Presbyterian church, Barrett taught Sunday school until she was 85. Although her brothers were more visible in town government, "it was only her gender that kept Aunt Elizabeth from being recognized as the brightest of the bunch," says Katharine Barrett Kelly, former town historian. (Courtesy Katharine Kelly.)

Like his siblings, Edward P. Barrett, born in 1875, was educated locally. He also attended the New York University School of Law. Lawyer, businessman, politician, gentleman farmer, and public activist, E.P. Barrett was a dominant figure in 20th-century Bedford. He was active in the early development of new Katonah, bringing electricity to the village through the Katonah Lighting Company. He was instrumental in the building of the Katonah Village Library and Memorial Park. E.P. Barrett served six terms as supervisor of the town of Bedford for an unprecedented 44 years, encompassing the Depression and World War II.

R.T. Barrett, born in 1877, is best remembered for his excellent commemorative history of Bedford, written on the town's 275th anniversary, in 1955. He was a writer and, in the tradition of his family, a community activist. He wrote for, among other publications, the *Katonah Record* and was active in the fire department, the Presbyterian church, the Village Improvement Association, and the Westchester County Historical Society. He was historian of the town of Bedford and served as president of the Bedford Historical Society. (Courtesy Katharine Kelly.)

According to the 1925 *History of Westchester County, New York* by Alvah P. French, "There is no better known lawyer in Westchester County, showing service to the cities, town and officials of the county, covering a period of twenty five years" than Henry Robertson Barrett. Born in 1869, he was active in Republican party politics and for many years represented the interests of private citizens of Westchester County in the long, drawn-out litigation with the New York City government over watershed rights. As a young lawyer working with his uncle, Judge Robertson, Barrett was involved with the proceedings condemning the old village of Katonah. He was successful in all cases, representing Westchester County interests in assessing the New York City government for confiscated lands. (Courtesy Katharine Kelly.)

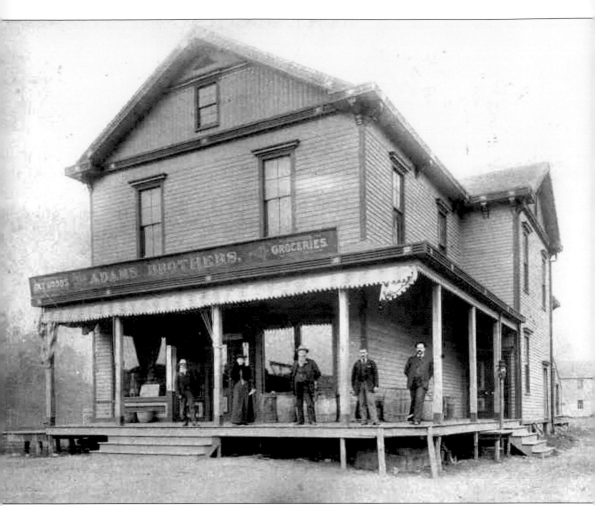

Everyone in town knew of the W.B. Adams & Son general store. It sat at the spot in Bedford Station next to the tracks and welcomed all visitors to town. The location of the Adams store is now approximately where the Bedford Hills post office sits. Farmers and travelers used Bedford Station as a hub of trade, and a stop was always made to the Adams store for general dry goods or to catch up on neighborly business. The post office was also housed in a section of the Adams store, and out back was B.A. Schenck's blacksmith shop. The owner, Walker B. Adams, was a responsible member of the community, serving as deputy postmaster and town clerk. Early in the morning on Thursday, August 20, 1896, Adams and his son William were surprised by a gang of desperate burglars entering their store. This group of four was well armed with 32-caliber revolvers and a superb set of tools including jimmies, chisels, and dynamite sticks. In the scuffle, both Walker and his son were shot. William returned fire and fatally shot two of the four robbers. Walker Adams did not survive the injuries to his head. William Adams, however, survived and was recognized as a hero. The events of that night are commemorated on a stone memorial directly in front of the Antioch Baptist Church across from the Bedford Community House.

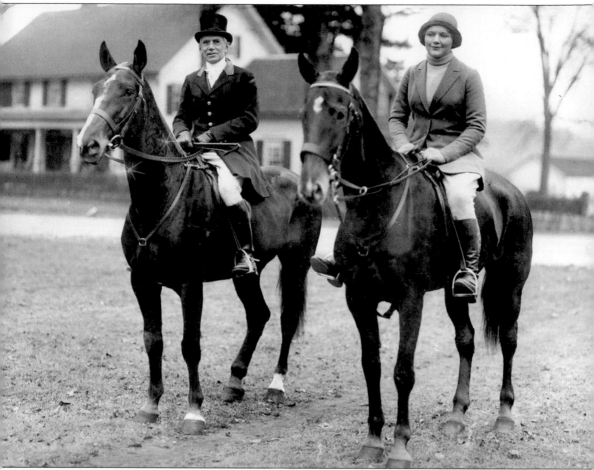

One woman who has maintained her large family land holding in Bedford is Wilhelmine Kirby Waller, and the land lies along Guard Hill and West Patent Roads. Wilhelmine Waller's father was Gustavus T. Kirby. Born in 1874 to an old Philadelphia family, Kirby came to Bedford as a child to spend the summers with his parents. He entered the Columbia School of Mines and met Seth Low, then president of Columbia University, and another Bedford resident. He was actively involved with the college sports teams. Kirby received degrees in both electrical engineering and law. But his love was sports. This love carried him to a global achievement in the world of sports. As a young lawyer with Gould & Wilkie, Kirby met and married Wilhelmine Claflin, the daughter of wealthy client John Claflin. They had one daughter, also named Wilhelmine. Kirby gave up law and pursued his interest in sports. Wilhelmine and the couple's daughter, nicknamed "Pud," accompanied Kirby everywhere. He served as president emeritus of the U.S. Olympic Committee. He founded the Public School Athletic League and encouraged schools nationwide to adopt sports programs in their curriculum. Kirby exposed his daughter to heads of states, popes, dictators, and nobility. Kirby's guiding theory was that sports and recreational activity could bring peace, understanding, and good will to the world. This philosophy allowed him to counter the strong anti-American feeling at the 1908 Olympics in London. He also self-assuredly took a strong stand at the 1936 Berlin Olympics. The U. S. Olympic Committee unanimously passed a resolution that if Jews were not allowed to compete in Berlin, the nation would not send any athletes. His stand was firm. In the end, Hitler changed his mind, and the United States did attend, as did Kirby and Pud. (Courtesy Wilhelmine Waller.)

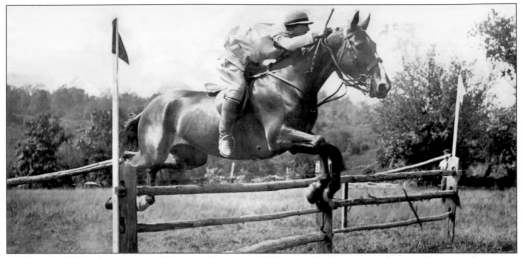

Willie "Pud" Kirby married Thomas Mercer Waller, and they moved into her grandparents' home, Tanrackin Farm. She inherited her father's love of athletics and became an accomplished horse rider. She devoted her life to Bedford and the land around her, serving on many boards and leading many conservation movements. She was first in line of a human chain to stop the building of Interstate 684, which threatened to violently push through fields and wetlands. She served as the president of the Garden Club of America and cherishes the miracle of the four seasons of Bedford, which she says gives her a reassuring faith in tomorrow and makes her aware of the infinite wisdom of nature. As this book was being compiled, she personally recalled her own history in Bedford and her involvement in the town's growth. Still an elegant woman, she hosts many annual meetings, serving afternoon tea and refreshments to those groups with which she was involved years ago.

The Edgar Hoyt family came to Katonah in the mid-1800s. Edgar and Hannah Hoyt were the first to establish a business in new Katonah on the south corner of Katonah Avenue and the Parkway. It was known as Pioneer House and was a popular restaurant. People came from far and wide to dine there. Hoyt's daughter Martha married Lloyd Bedford Cox, and they made their home in Bedford Hills. Their son, Lloyd Bedford Cox Jr., lives in Bedford Village and is a past president of the Bedford Historical Society. Lloyd Cox Sr. is seen here with Moyca Newell, who was one of the two women instrumental in founding the New York State Police. (Courtesy Lloyd B. Cox Jr.)

112

Nehemiah Lounsbery was one of Bedford's earliest residents. In 1740, he moved from Rye and built a home on Guard Hill Road on the site that is now known as the Kirby house or Tanrackin Farm. He allowed the American troops to occupy the house and neighboring hill during the Revolution. Many of Nehemiah's descendants have remained in Bedford. Henry R. and Richard P. Lounsbery were members of the Bedford Lawn Tennis Club. Henry was also one of the five people who founded the Bedford Golf and Tennis Club in 1896. Henry (seen here) was a natural athlete, winning numerous golf and tennis tournaments at the club. Working in New York, first with a stockbroker, then beginning his long real-estate career, Henry established a successful New York real-estate firm. His daughter Beatrice inherited her father's athletic ability and also his interest in real estate. After she married John Renwick, she started the real-estate firm Beatrice L. Renwick in Manhattan and in Bedford. Her son John took over the firm, and it is now run by her grandson Jim Renwick. Both John Renwick Jr. and Jim Renwick are former presidents of the Bedford Historical Society.

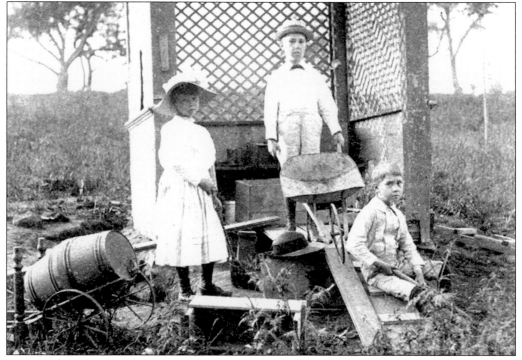

Seen in this photograph are some young members of the family. They are, from left to right, Edith, Ben Ali, and Dick Lounsbery. (Courtesy John Renwick.)

Two significant contributors to the town of Bedford and the Bedford Historical Society in more recent times are Donald W. Marshall (seen here) and H. Halsted Park Jr. Marshall served as town historian for a quarter century and was responsible for the publication of nine volumes of the Bedford historical records. Park was president of the historical society, during which time he led the effort to have Bedford Village designated a historic district and named to the National Register of Historic Places. Under his presidency, the historical society acquired an additional three buildings in the historic district, including the post office. It was also Park who led the movement for the restoration and preservation of the 1787 Bedford Courthouse.

Clarence Whitman, who moved from New York to Katonah's Wood in 1891, is credited with leading villagers to move their homes from old Katonah to a newly laid-out village. He formed the Katonah Land Company with W.H. Robertson, Samuel B. Hoyt, and Albert Hoyt as directors. They negotiated a land purchase from the New York City and hired the architectural firm of B.S. and G.S. Olmstead to plan streets and housing lots. Whitman had tremendous foresight and was a visionary in town planning. The directors of the Katonah Land Company arranged for restrictions on types of businesses allowed in the new Katonah to make it a pleasant community in which to live. These restrictions banned the manufacture of gunpowder, soap, candles, and glue. The selling of liquor was also forbidden, which is why the only liquor store in Katonah sits on the property of the old railroad station. Planners also restricted the tanning of leather and the keeping of swine, vicious dogs, or chickens. They encouraged residents to take pride in the new avenues and walks of this new village. Katonah today is vibrant and thriving due to the wise planning and foresight of Whitman and the land company directors more than 100 years ago. (Courtesy Cindy Swank.)

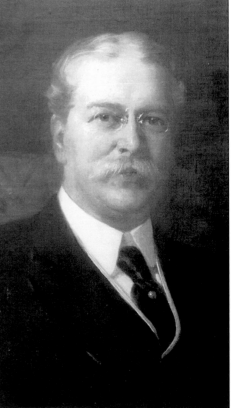

Nine

AN OUTDOOR LIFE

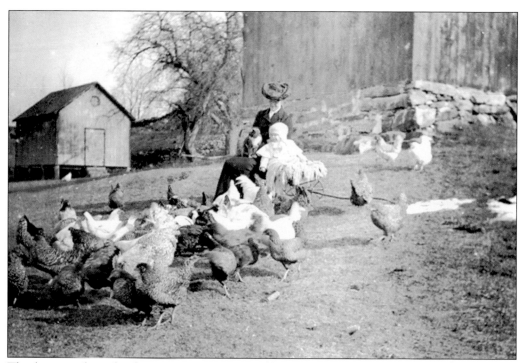

The beauty of our land creates a respect we all carry far beyond the reaches of progress or economics. From 1680, when the original founders laid out our first town in the Puritan tradition to the condemnation and flooding of old Katonah, thus creating a new hamlet, town forefathers have displayed tremendous foresight. As the town changed from an agrarian landscape to country estates to a suburban commuting town near New York City, planning continued to shape Bedford. It has always been home to thinking people who have shaped their world. Institutions, foundations, schools, and clubs have been created by these thoughtful residents. They have not taken the beauty of their town for granted and were among this country's first environmentalists. It is by no accident that Bedford residents can claim to be founding members of the Nature Conservancy and the Audubon Society. The early American history, the rich natural resources, the beauty of its open landscape, the strong character of its people, and the continued dedication to plan for the future all make Bedford the special town it is. Here we see the beauty of farm life at Maple Grove Farm as young Palma Hope Lewis enjoys her animals.

The beautiful land of farms and woodlots north of Bedford in Pound Ridge and Lewisboro fell to speculators in the early 1900s. Between 1900 and 1909, there were rumors that a rail line would be coming from Bedford Village to Danbury, Connecticut. The frenzy to realize profits on this land made farmers sell out to speculators. Development plans were filed to split these large tracts of farmland into suburban parcels of 25 by 100 feet. Fortunately, the railroad never came, and financial difficulties halted the developers before they had a chance to destroy the land. Much of the acreage after 1915 was sold at auction. At the urging of William L. Ward, who was the Republican county leader, Westchester County bought more than 4,000 acres of farm and woodland in 1925 for a county park. The first thing the county did in the reservation was plant 12 acres of buckwheat and millet to feed the wild birds. Nature trails were developed. Eloise Luquer and Delia Marble led a team to develop a wildflower garden. The entire area has been kept as natural as possible. From 1933 to 1938, a Civilian Conservation Corps camp was in the reservation. The corps cleared brush, cut hiking trails, reforested some of the open areas, and built lean-to shelters. The corps also built the Trailside Nature Museum with funding from the Bedford Garden Club and the Department of the Interior. (Courtesy Ward Pound Ridge Reservation.)

The fledgling group of conservationists and scientists organized under the name of the Nature Conservancy made their first purchase of land in Bedford, known as the Mianus River Gorge, in 1954. This purchase was the birthplace of the Nature Conservancy's method of direct-action conservation and launched the national organization to become the force it is today. The first land donated to the Nature Conservancy was also in Bedford a year earlier. It is now the Arthur W. Butler Memorial Sanctuary and was given by Mrs. Butler in memory of her late husband. The original gift was 225 acres, but with the work of the late Thomas W. Keesee Jr., chairman of the sanctuary's board of trustees, an additional 107 acres was added. At the first meeting of the Nature Conservancy, it was proposed that the group begin preventing introduction of nonnative plants and animals to the United States. To preserve native species, land would need to be protected. The resolution was adopted and became part of its mission. By 1961, more than 10,000 acres had been protected. In 1983, the conservancy received its first major grant of $25 million to carry out the mission. By 1999, membership had surpassed one million members. Every state has a chapter, as well as many foreign countries. Today, the Nature Conservancy has built the largest sanctuary system in the world.

The Mianus River Gorge Preserve is a unique and primeval old-growth hemlock forest in a protected ravine. Led by Gloria Anable of Greenwich, Robert Hamerschlag, James Todd Jr., and Edna Edgerton, a group of local residents mobilized to raise funds to purchase this special land at the Mianus River when it was threatened to become a housing development in 1953. Funds were raised overnight from private sources and from the fledgling, now national, group of the Nature Conservancy. These dedicated conservationists preserved 60 acres of land surrounding the Mianus River. Since 1954, there have been 73 subsequent parcels added to the preserve, totaling 760 acres today. Although once farmed and even mined, now the gorge is a wild ravine containing a grove of old-growth hemlocks, more than 150 bird species, and wonderful plant diversity. In 1964, it was registered as a National Historic Landmark, the first natural area to be so designated. This photograph shows a section of the Mianus River Gorge in 1887. The gorge can be visited today from April to November. The entrance is on Mianus River Road just off Miller's Mill Road.

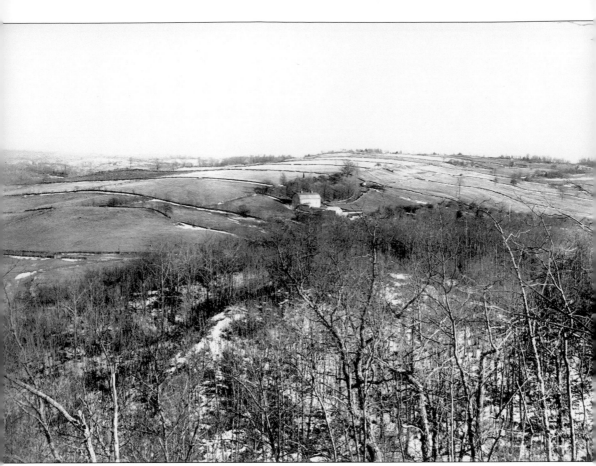

On the occasion of the Bedford Audubon Society's 90th anniversary, John Askildsen, Audubon's current director, recalled the founding of this first environmental group in town. "Originating in 1913, the Bedford Audubon Society resulted from a fear that too much of Bedford's land was becoming deforested for farming and therefore unfriendly to its bird species. Leadership quickly recruited many of Bedford's leading citizens to join this movement." Founding members included Mary A. Clark, William Fahnestock, Charles Haines, Mr. and Mrs. C.W. Wheeler, Mr. and Mrs. Henry Lounsbery, Eugene and Agnes Meyer, Mrs. James Wood, Mrs. Joseph Lapsley, Mrs. William Sloan, Delia Marble, and Eloise Luquer. Although preservation of local bird life was central to the Bedford Audubon Society's original mission, the first Friday of the month quickly became known as "Audubon night" and was quite the social event. Today, the Bedford Audubon Society actively sponsors lectures and events and is located on Bylane Farm and Audubon Preserve on Todd Road.

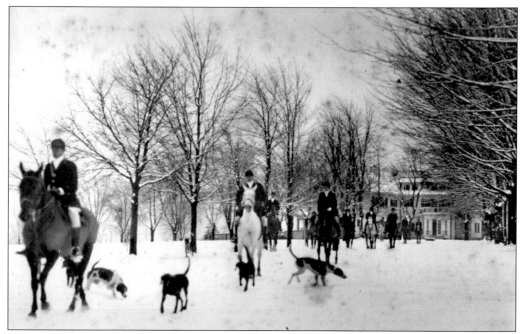

The equestrian area of Westchester was organized and divided by the American Fox Hound Association into districts. The local hunt clubs in the area included the Fairfield and Westchester Hounds and the Goldens Bridge Hounds. Local horse shows were the Whip and Spur and the Tanrackin Horse Show. Sunnyfield Farm hosted steeplechase events. The Bedford Riding Lanes Association (BRLA) was formed to maintain the necessary riding paths open for horse and rider to travel to local horse shows, and it connected most neighboring farms. Here we see the Bedford Whip and Spur Hunt begin from Tanrackin Farm. (Courtesy Wilhelmine Waller.)

The outside course of the Tanrackin Horse Show is underway along the trail from Tanrackin toward West Patent Road. John Renwick has just completed his jump on the silver horse. In front of him is Edward Munro and behind him is Cleveland Cobb. (Courtesy Wilhelmine Waller.)

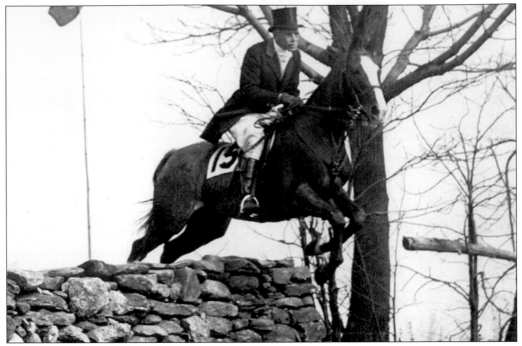

Gustavus Kirby clears a fence at the Tanrackin Horse Show.

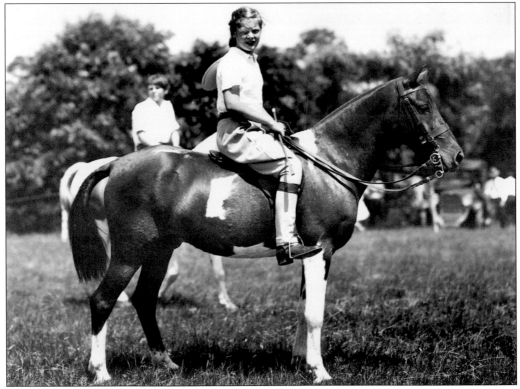

Seen here is a young Dorothy Butler (Harder) at the Bedford Whip and Spur Horse Show *c.* 1932, with Ettore Grassi in the background.

The stylish spectators watching their young family members ride at Tanrackin are, from left to right, Mrs. Baldwin, Mrs. Bellamy, Mrs. Kirby, and Mrs. Ewing. (Courtesy Wilhelmine Waller.)

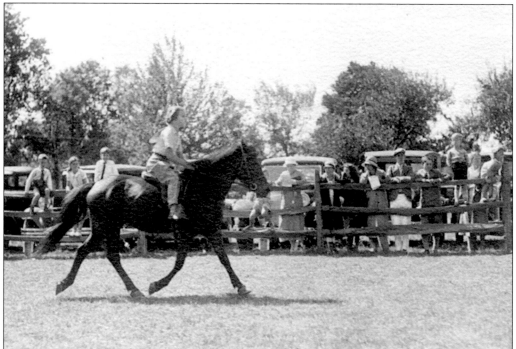

Young Polly Harrison (Winans) and her lively pony June finish a perfect course for her many fans. (Courtesy Wilhelmine Waller.)

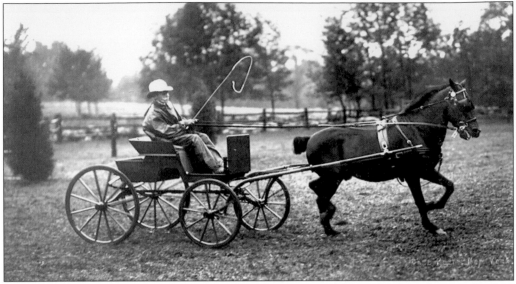

The Tucker family has lived in Bedford for generations and has contributed to much of its history and character. The family estate, Penwood, was located on 120 acres of land off McLain Street, which is now a development. Here we see Carll Tucker Jr., with Dash pulling the cart, in 1934. (Courtesy Wilhelmine Waller.)

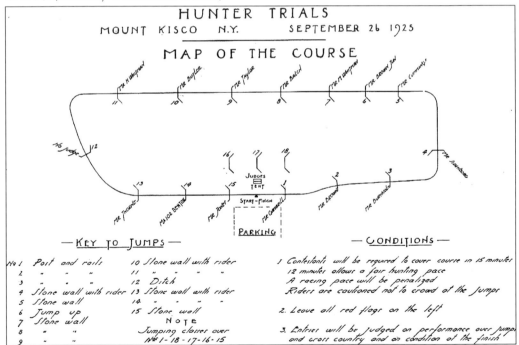

Dotty Harder shared her program for the Hunter Trials with us. It was organized by the Fairfield and Westchester Hounds and held on their course located off of Sarles Street. Because the local equestrian events were such an event, elegantly dressed residents arrived in their new motorcars and planned to stay for the day. The food became quite elaborate and was served out of their cars. Acquiring a good parking spot was quite important to fully enjoy the day. At the Hunter Trials, Gustavus Kirby holds the prized first-place spot.

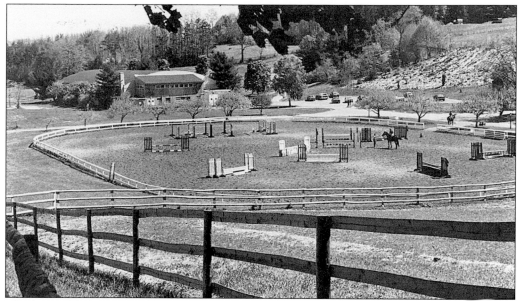

The beautiful farm we know today as Sunnyfield at South Bedford Road, Clark Road, and Route 22 was once a large dairy operation but became a known horse-breeding farm at the turn of the century. An annual steeplechase event was held here along with a few shows. It continues to be open fields and paddocks supporting a breeding operation along with housing a world-class dressage-training center. On a walk through the woods of Bedford, one can still find a rare milk bottle from the dairy days.

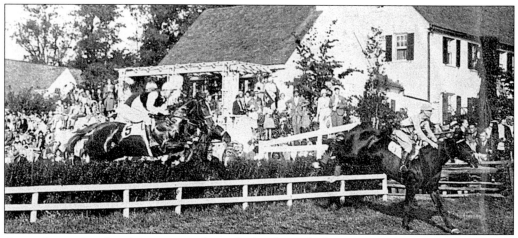

A popular weekend activity was watching the local steeplechase events. Here, a group of horses clears a fence near a home on Guard Hill Road. The old brick Virginia-type house was called Ensign Farm and was owned by the Gibson family.

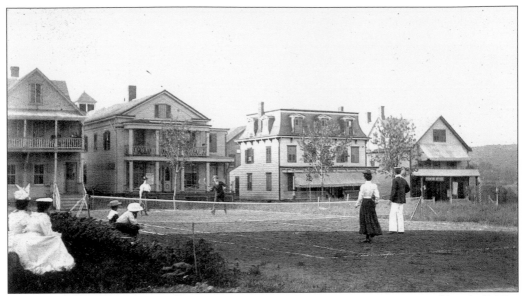

Two well-organized sports in Katonah at the turn of the century were tennis and baseball. The courts of the Katonah Tennis Club are pictured here across the tracks in new Katonah in 1896.

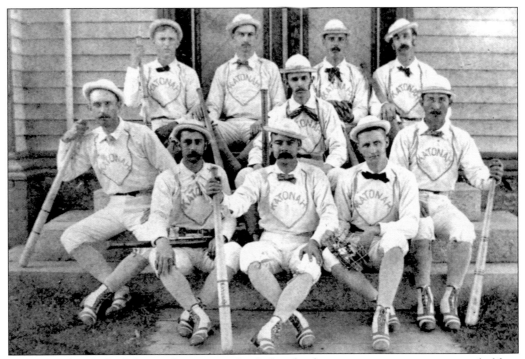

The local baseball club was known as the Lakesides because team practices were held at Lakeside Field. The field, which is now gone, was located under the Saw Mill River Parkway. The team photographed here is believed to be the Lakesides. Seen here are the following: (front row) George Miller, Harry Green, and Thad Green; (middle row) Byron Travis, L.M. Brundage, and Charles Flewellin; (back row) Jim Caldwell, John Kelly, Charles Wickware, and an unidentified gentleman. (Courtesy Katonah Historical Museum.)

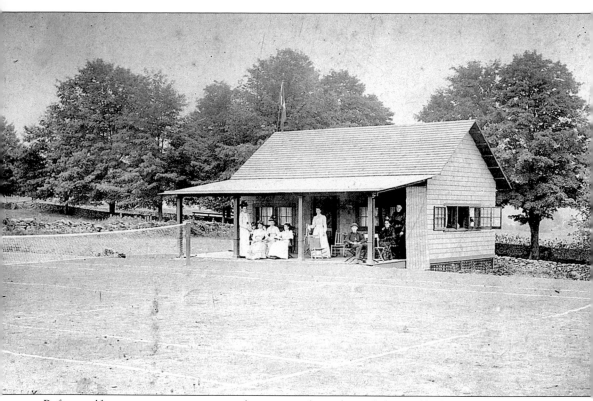

Before golf came to town, a group of young residents formed the Bedford Lawn Tennis Club. This evolved into the Bedford Golf and Tennis Club in 1896 as the game took hold in New York. Among the original five founders were Henry R. Lounsbery, Col. Thatcher Luquer, and Thomas Kirby. All three have had their name attached to many other organizations in town. The group obtained its first lease for land, large enough to create six golf holes, from George Worden. Additional land was received from Richard Lounsbery to finish out the nine holes. In the 1920s, a golf architect named Devereux Emmet was hired to build the second nine holes and turn the Bedford Golf and Tennis Club into a superb 18-hole course. Emmet designed several of the nation's finest golf courses of the day, including Bonnie Briar in Larchmont and the Broadmoor in New Rochelle. The Bedford course was challenging and was known for having abrupt elevation changes. The club has held golf tournaments for more than 100 years with a brief break during World War II. Tennis has continued to be played avidly since 1891, and Bedford has produced many nationally ranked players. This photograph shows the Progress of Women's Metropolitan Golf Association championship in front of the clubhouse in the 1920s.

The Bedford Garden Club was founded in 1911 "to stimulate the knowledge and love of gardening among amateurs, to aid in the protection of native plants and birds, and to encourage civic planting." Garden clubs were rare in those days. Mrs. Frank Potter was the club's first president and served from 1911 to 1916. Other original members were Eloise Payne Luquer, Delia W. Marble, and Evelyn Leonard. For more than 90 years, the club's members have spearheaded numerous conservation endeavors and have been active citizens in Bedford town planning. There are currently only a few clubs as old as the Bedford Garden Club. In 1913, the club was one of the charter members of the Garden Club of America.

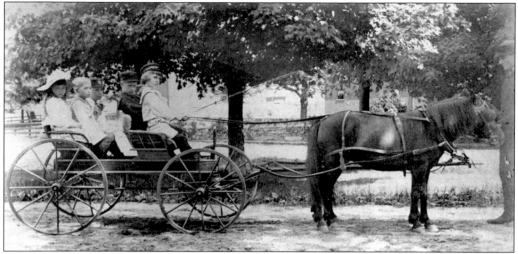

Pictured are James Lounsbery Jr. and his ponies. Riding along are Ben Ali Lounsbery, Edie Dick Lounsbery, and little Harry Lounsbery. (Courtesy John Renwick.)

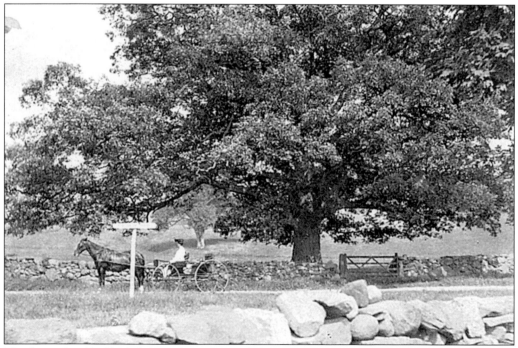

The legendary Bedford Oak at the corner of Hook and Cantitoe Streets is 130 feet high and more than 23 feet around. The white oak was thought to have been roughly 200 years old when Bedford was purchased from the Native Americans in 1680. In 1947, the ground on which the Bedford Oak stands was deeded to the town by Harold C. Whitman in memory of his wife, Georgia Squires Whitman. Two acres behind the oak were donated to the Bedford Historical Society as open space to further protect its root system. Unfortunately, the traffic along Route 22 and a parking area over the oak's front root system are undermining its health. The Bedford Oak has witnessed enormous change over its 500 years, and we wish it many more years of good health.

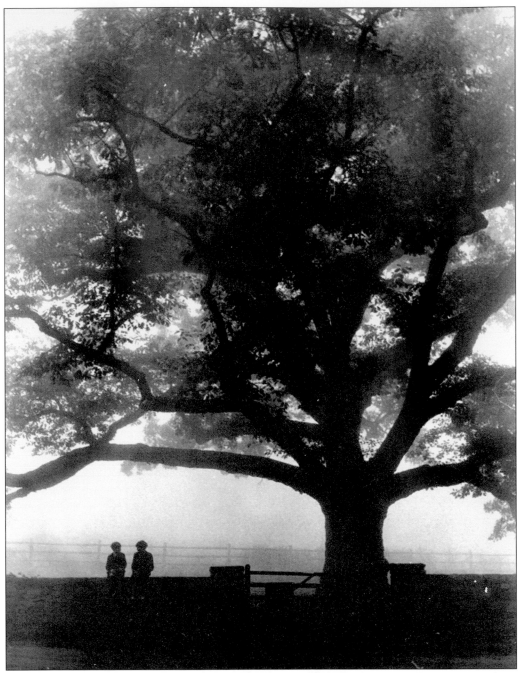

Wilhelmine Kirby Waller shared with us the following: "How sad that so many of us in our busy adult world let the miracle of the four seasons unfold before our eyes without recognizing its wonder. How tragic if in the bustle that engulfs us, we lose our appreciation of the perfection and beauty of a single rose. Those of us who live in this beautiful town of Bedford should find time for an occasional walk through the woods and fields that surround our homes. This, if we keep our eyes and hearts open, is a stabilizing experience, for the eternal fitness of the laws of nature is visible on all sides."